All Over Coffee

Book design by Alvaro Villanueva
Cover design by Paul Madonna
Printed in Singapore

Library of Congress Cataloging-in-Publication Data

Madonna, Paul, 1972–
 All over coffee.
 p. cm.
 ISBN-13: 978-0-87286-456-6
 ISBN-10: 0-87286-456-1
 1. Comic books, strips, etc.–California–San Fran-
cisco. 2. San Francisco (Calif.)–In art. I. Title.

NC1429.M1557A4 2006
741.5'6973–dc22

2006100503

Visit our website: www.citylights.com

City Lights Books are published at the City Lights Bookstore,
261 Columbus Avenue, San Francisco, CA 94133.

All Over Coffee

by Paul Madonna

City Lights Books
San Francisco

There is the life you think you lead, and then there is the one you really do. The first is made of solid dots—your home, your dog, your office—that connect in a straight and pleasing line for months and years, forming the sensible narrative of a life. Details that do not help the story—telephone wires, bus delays, someone else's receipt falling from a used paperback—are left out. It is a neat fantasy. It is, in its way, quite beautiful.

But Paul Madonna remembers what you forgot. You may edit them out, but you spend more time looking at telephone wires, at buildings seen between other buildings, at painted curbs and fireplugs, than at your own beloved dog. You say and think things very unlike yourself, and overhear conversations unrelated to that carefully revised version of your life. You make sure they are forgotten. But they are not forgotten. They are in this book.

Madonna's images and text relate in an as-

tounding way. As in the work of the novelist W. G. Sebald, neither do the words narrate a picture, nor does the image illustrate the words. Instead, they are each meant to turn the other sideways, pointing not to any specific event or storyline but to a moment in which the two might coexist. For instance: in one frame we are shown the cut-off view of a building, trees and part of a cross; we are also given the end of a thought about space. Is this the setting for that thought? Are we meant to remember the stars in that day sky? What about the cross? The fact is that both parts are incomplete and, like the broken lines of a poem, produce the pleasure of multiple connections. Like the poem, it rewards revisiting. None of this would work if the text were not so carefully conceived, or the images so painstakingly conjured; it could only take a novelist and artist to produce them. The clear dedication and talent at work is what calls for careful attention to these pages, both admiring the words and artwork

and enjoying the connections they spark. It is no more than the attention we always give to art. In return, what Madonna provides is more than what is on the page; there is another dimension present, lending each work a sculptural effect. Two beautifully crafted objects are set before us on the page, at rest. There are no people present, no wind, no motors to move them. What sets them in motion, through a series of connections and memories, is our mind.

This book is not in black and white, though it may at first appear that way. In fact, color is a crucial part of its beauty. Like the initials of the title, color makes its secret cameos throughout the work, sometimes in hidden details, sometimes appearing sublimely all across a page, but I recommend also looking for its subtle progress in the ink washes. In each of them, as with the images in our mind's eye, emotion adds a hidden depth.

—Andrew Sean Greer

All Over Coffee

ALL OVER COFFEE launched in the *San Francisco Chronicle* and on SFGate.com February 8, 2004. Immediately, letters of praise, confusion, and disgust poured in. Angry voices brought out voices of support, and debate over the strip took on a life of its own. The strip ran in the Datebook section four days a week for one year, then three days a week for six months before settling into its current position of one day a week in the Sunday Datebook.

Note about the pieces:

On the bottom of each piece is the print date and number of strip. Daily and Sunday pieces were thought of as different series and numbered accordingly. Letters "d" for daily, and "s" for Sunday precede piece numbers. Some strips form a series. Those strips have a "t" for text series, followed by a series number, then an indication of its placement within the series.

7.29.04	d0080	t005	3 of 3
print date	*strip #*	*series #*	*strip # within series*

This collection represents a selection of 151 strips from the 320 at the time of collecting. For the most part, strips are presented in order of publication date. In a few cases, pieces have been placed out of order to help the flow of the book. More on this is in the "Collecting" section of the afterword.

The afterword also details the story, development, and process of ALL OVER COFFEE.

—Paul Madonna, San Francisco, 9.17.06

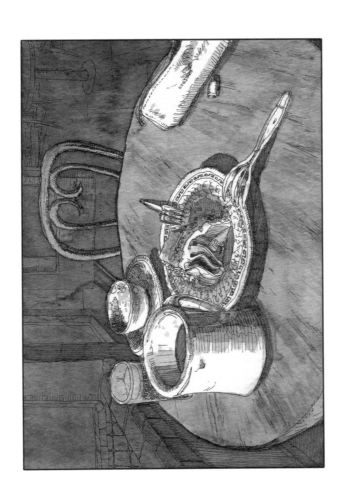

Maurice sips mocha latte at his favorite cafe and argues with a man in shorts

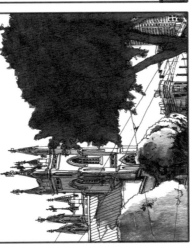

"I'm sick of you unobservant transients," he says, "San Francisco does *Too* have seasons!"

It almost comes to blows

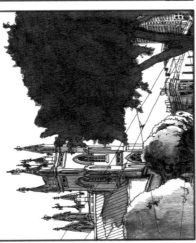

Almost
It settles over a slice of tiramisu when they both agree that Kundera can't end a novel.

10.03

All Over Coffee

002

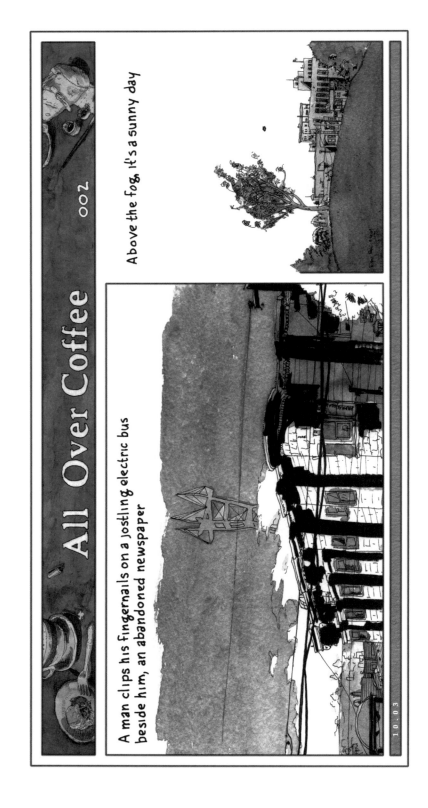

A man clips his fingernails on a jostling electric bus beside him, an abandoned newspaper

Above the fog, it's a sunny day

10.03

All Over Coffee

Outrage over the recent public art project "Used Laptops" hit a peak yesterday when one of the devices was thrown from a 12th story window in Union Square.

400 laptop computers cycling through thousands of porno- graphic images were abandoned in cafes across the city last Friday.

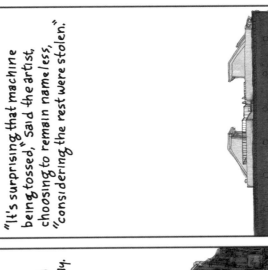

"It's surprising that machine being tossed," said the artist, choosing to remain nameless, "considering the rest were stolen."

All Over Coffee

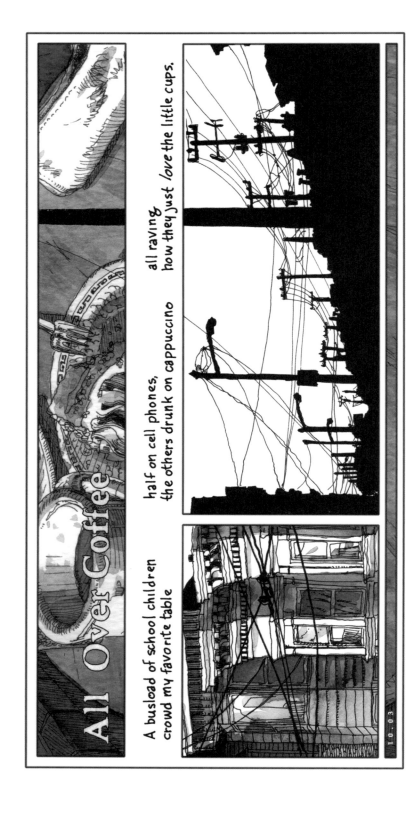

A busload of school children
crowd my favorite table

half on cell phones,
the others drunk on cappuccino

all raving
how they just *love* the little cups.

10·03

All Over Coffee

005

She would buy a two-dollar chocolate bar from the middle school boys;

they even have her favorite, with almonds.

But money is tight, and those things always give her gas.

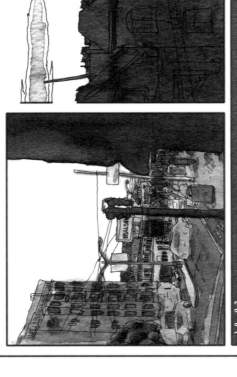

10.03

All Over Coffee

The little man said to the monster:
I come from a terrible place.
We tear ourselves inside out for something the
world may love, then base our worth on that.

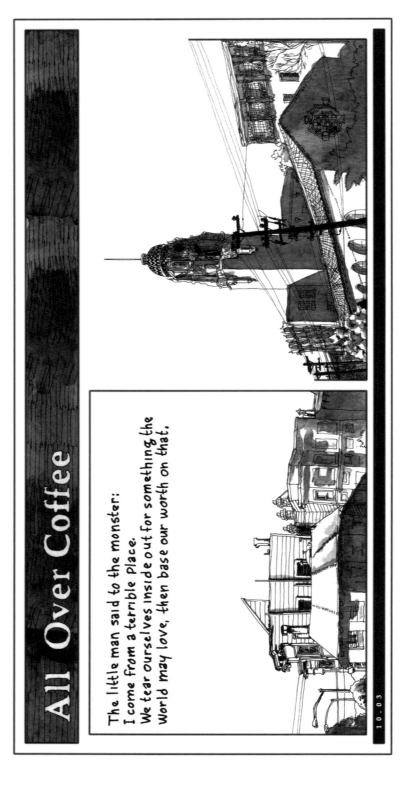

10.03

Do actors who are continually cast as villains feel lesser about themselves?

As a child I thought bad guys in movies were convicted criminals.

So whenever maiming or murder was inflicted upon them, that was their punishment.

It all seemed justified in the name of entertainment.

sool - 2.8.04

All Over Coffee

Beside the register hangs a calendar
of pregnant women on used cars

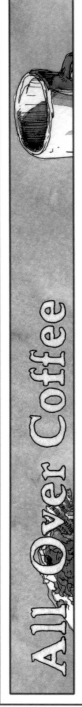

The coffee has rainbow bubbles
like oily water in the sun
like dish soap

and everyone here will have '80s music in their head for days.

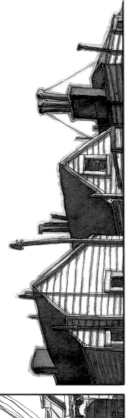

008 — 2.11.04

All Over Coffee

"I don't get superheroes," she says, "If you could see through everything you'd see nothing at all."

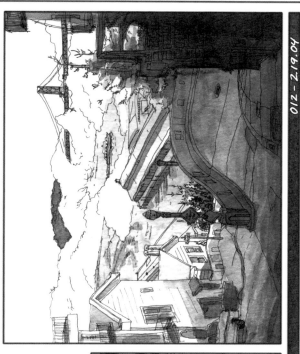

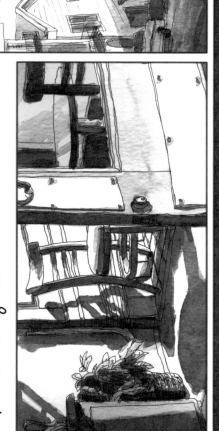

012 - 2.19.04

20

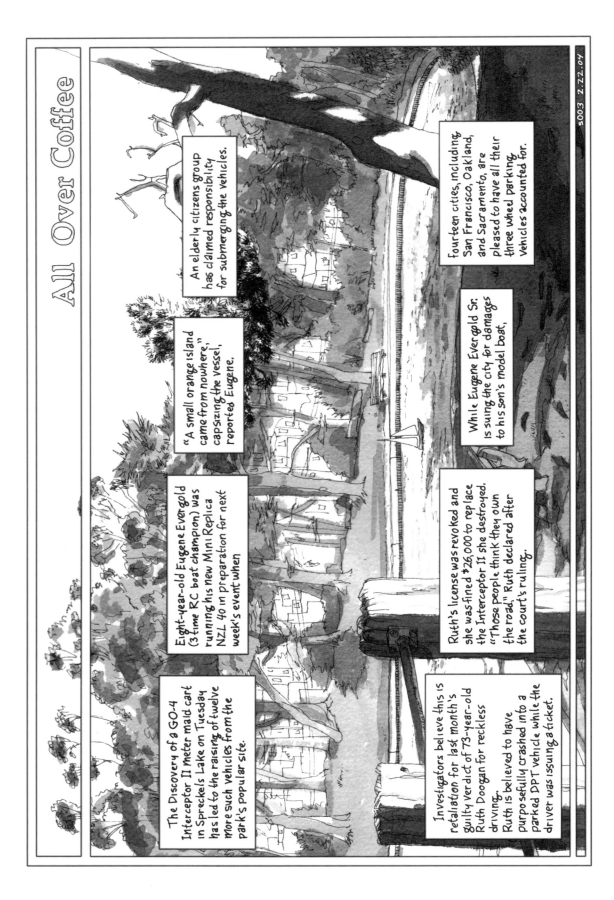

The Discovery of a GO-4 Interceptor II meter maid cart in Spreckels Lake on Tuesday has led to the raising of twelve more such vehicles from the park's popular site.

Eight-year-old Eugene Evergold (3-time RC boat champion) was running his new Mini Replica NZL 40 in preparation for next week's event when

"A small orange island came from nowhere," capsizing the vessel, reported Eugene.

An elderly citizens group has claimed responsibility for submerging the vehicles.

Fourteen cities, including San Francisco, Oakland, and Sacramento, are pleased to have all their three wheel parking vehicles accounted for.

While Eugene Evergold Sr. is suing the city for damages to his son's model boat,

Ruth's license was revoked and she was fined $26,000 to replace the Interceptor II she destroyed. "Those people think they own the road," Ruth declared after the court's ruling.

Investigators believe this is retaliation for last month's guilty verdict of 73-year-old Ruth Doogan for reckless driving.
Ruth is believed to have purposefully crashed into a parked DPT vehicle while the driver was issuing a ticket.

All Over Coffee

Sarah returns home frustrated, with the intention of having chicken, a muffin, then coffee

Instead she eats cereal until bloated and reads the New Yorker.

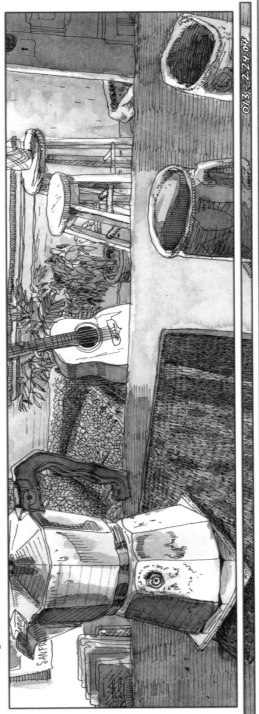

013 – 2.24.04

All Over Coffee

She remembers being young and unable to breathe;

but now the muscles in her face don't seem to work.

Over breakfast she's silent, says she's preoccupied, thinking about happiness.

01.4 – 2.25.04

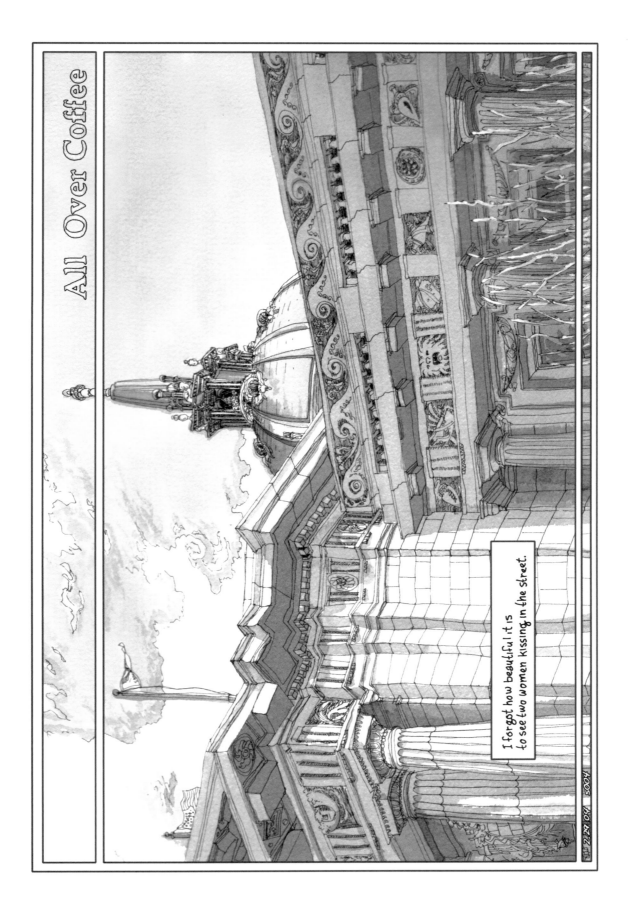

I forgot how beautiful it is
to see two women kissing in the street.

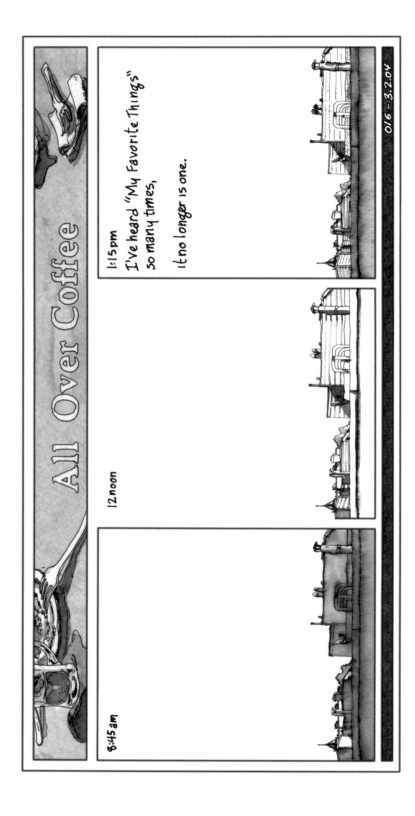

All Over Coffee

8:45 am

12 noon

1:15pm
I've heard "My Favorite Things"
so many times,

It no longer is one.

016 – 3.2.04

All Over Coffee

He wants to see her again,
but can't stand the smell

I'm not toying with them she says,
I give them hope
Then laughs hysterically

She works in a retirement home,
has huge breasts,
and her hands smell of industrial
soap

All Over Coffee

Somewhere in space:
(after interplanetary travel becomes commonplace)

A cargo load explodes

Sending thousands of novelty toys with spring-loaded heads to a new destiny.

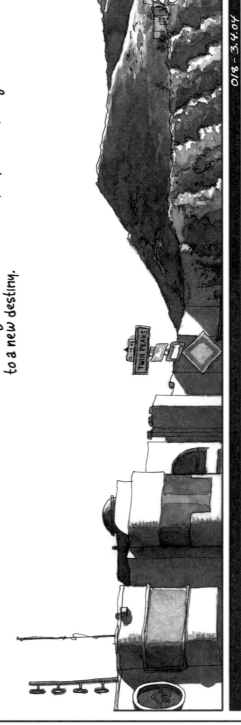

018 – 3.4.04

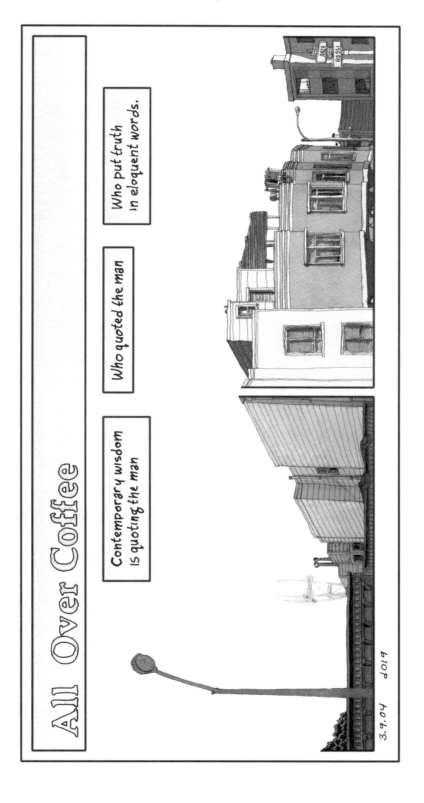

All Over Coffee

Contemporary wisdom
is quoting the man

Who quoted the man

Who put truth
in eloquent words.

3.9.04 d019

All Over Coffee

Set your ideals
to those of the image of your idol

Pull your collar tight

And walk into the storm.

3.7.04 s005 Panorama(p)001 1 of 2

All Over Coffee

It's absurd to think that all people believe in fairness

But not as absurd as thinking that they have the same definition for it.

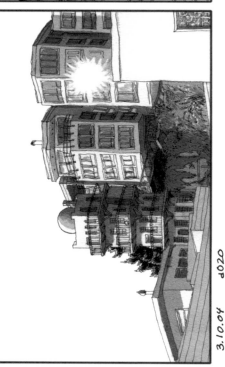

3.10.04 POP

All Over Coffee

The hardest part for the living
is feeling dead

And that those whom we're
dead to

Keep on living.

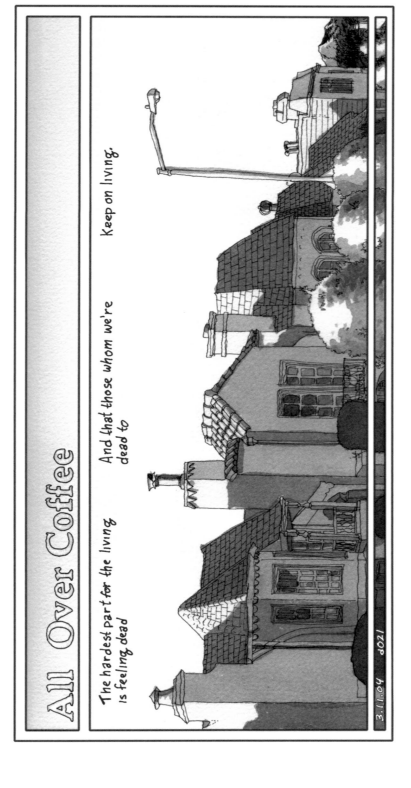

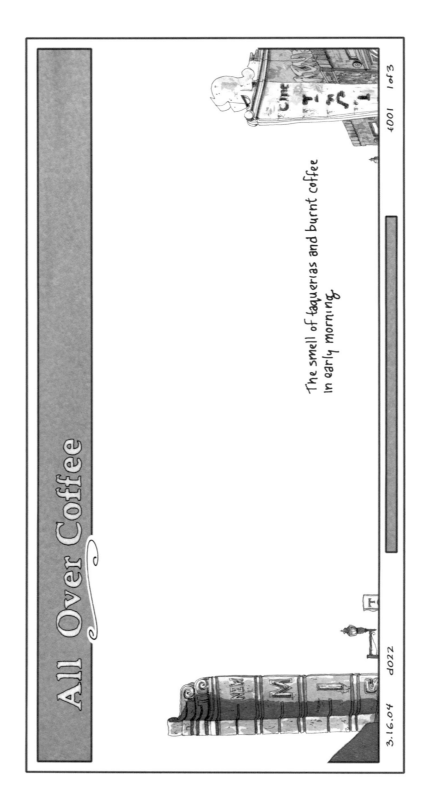

All Over Coffee

The smell of taquerias and burnt coffee in early morning

All Over Coffee

After the Cherry blossoms faded,
and the wind eased,
a March sun took over

A respite from the poison

Of what Miller calls
"vicious dreams."

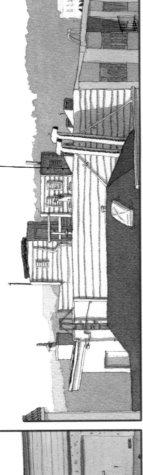

3.17.04 d023

All Over Coffee

A woman behind me has a voice like
Cindy Williams in "The Conversation"

And the fog blows back in.

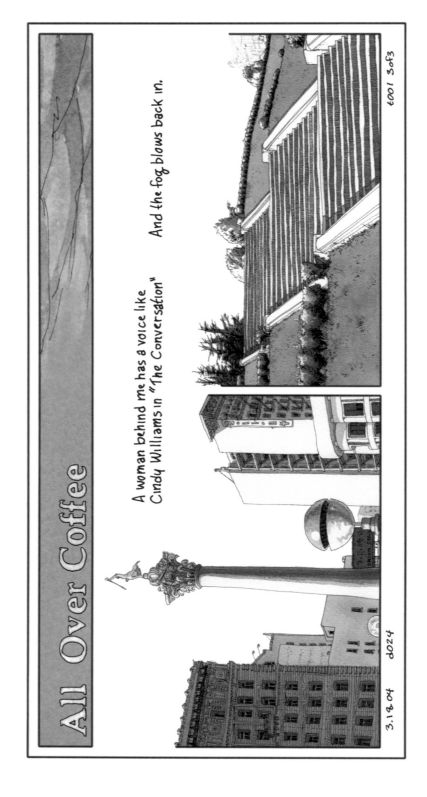

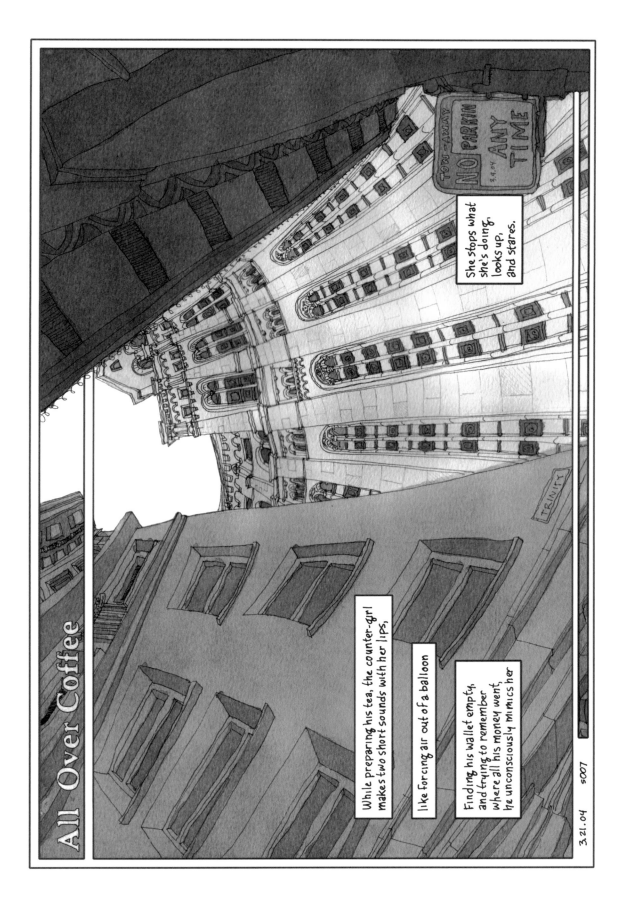

All Over Coffee

While preparing his tea, the counter-girl makes two short sounds with her lips,

like forcing air out of a balloon

Finding his wallet empty, and trying to remember where all his money went, he unconsciously mimics her

She stops what she's doing, looks up, and stares.

All Over Coffee

Maurice flips through the paper
"Another movie about heroin," he says

"How do they do it?"

"Music I can understand,
but a film's a lot of work."

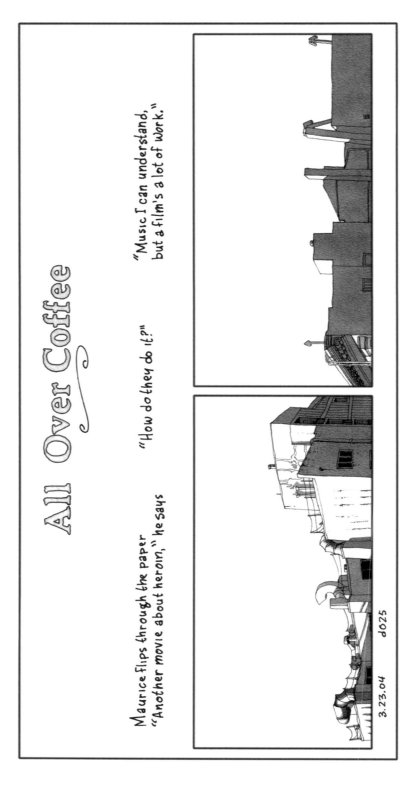

3.23.04 d025

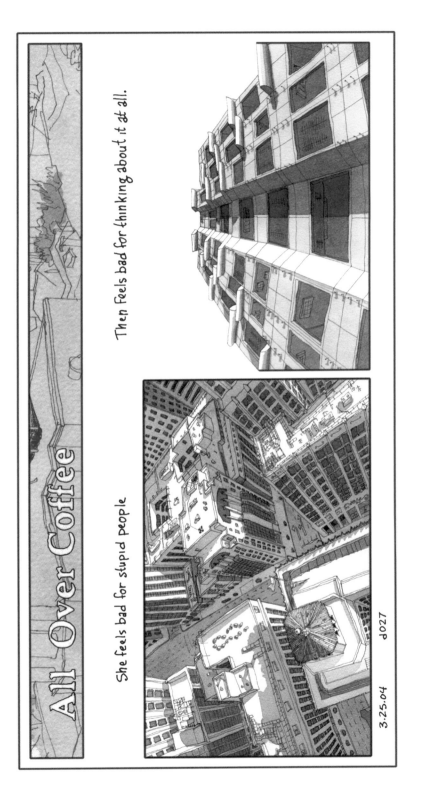

All Over Coffee

She feels bad for stupid people

Then feels bad for thinking about it at all.

All Over Coffee

He saw her again today at Maurice's cafe,
but this time took a breath and walked over

Smiling, he said,
"I saw you in here last week,
but didn't say anything"

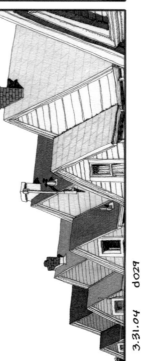

3.31.04 d029

She looked up and replied, "I know."

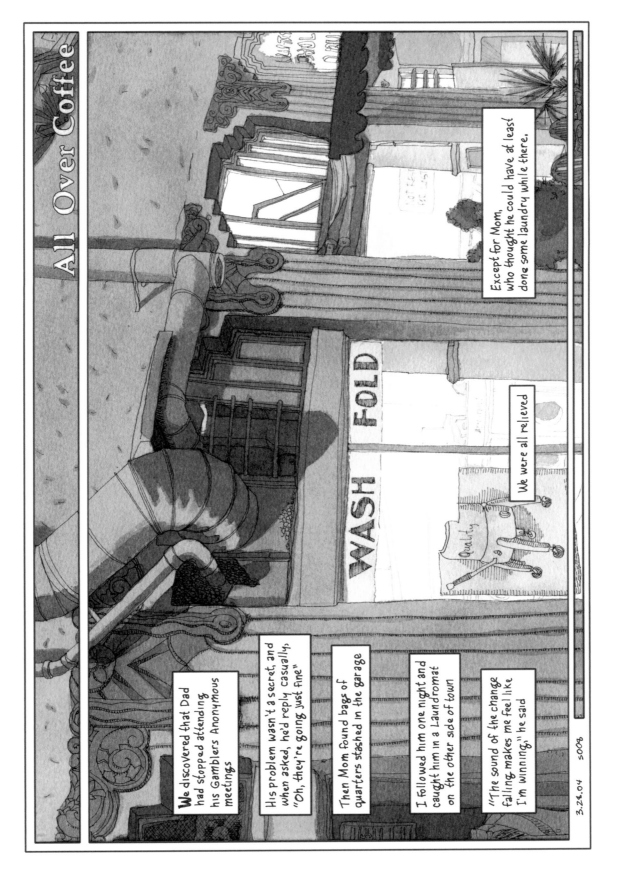

3.28.04 s008

All Over Coffee

"The world is going the way of satellite-tracking and robot armies, and I'm trying to make something beautiful."

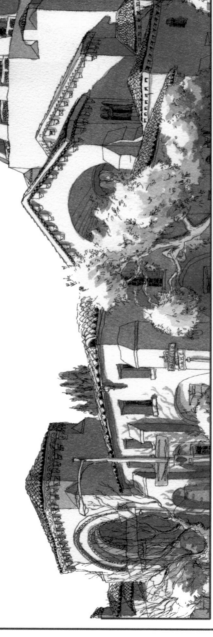

4.7.04 do31

All Over Coffee

"The last time I saw you,
we sat in my car in the rain,
you paid me back the money you owed,
and we sang with the radio."

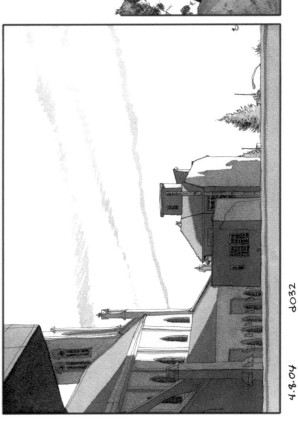

4.8.04 d032

All Over Coffee

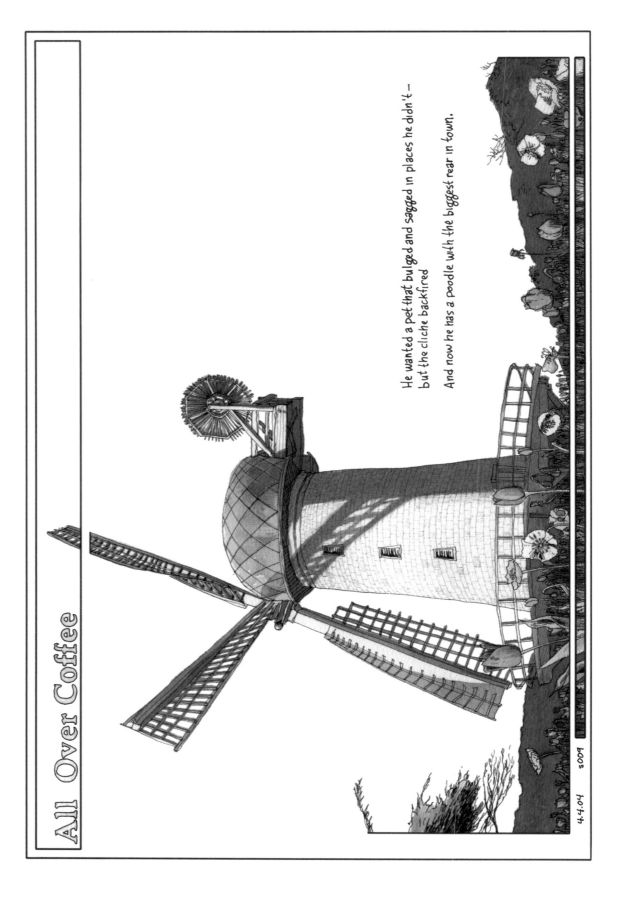

He wanted a pet that bulged and sagged in places he didn't —
but the cliché backfired

And now he has a poodle with the biggest rear in town.

soos

4.0.4

All Over Coffee

"...so is it War War 3 or 4 that we're headed for? I can never remember"

"WORLD War, honey"

"What?"

"It's World War we're headed for, not War War"

"Oh."

All Over Coffee

He hopes the celebrities of
his childhood invested well—

Life is filled with enough heartbreak,
without stumbling into a corner store
to find one stocking shelves.

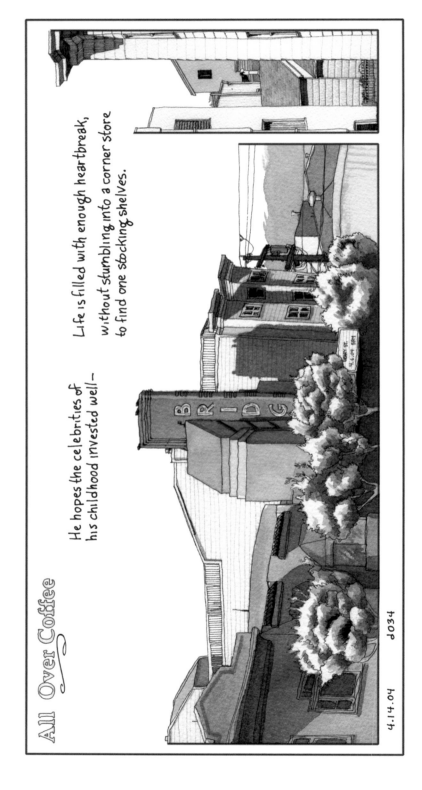

All Over Coffee

After her mother left, Sarah had to take care of her father, as well as herself.

She was seven.

She ran her father's bath and made rudimentary lunches, while he laid on the couch, appearing less and less aware as the days went by.

He started coming around the following spring; his eyes pushed out of their sockets as if every muscle in his body were focused on seeing.

He began dressing Sarah as a princess for school in the morning — an act frighteningly strange to her, not just because of the long gown and plastic crown, but because she had been acquiring her own clothing, as well as dressing herself, for eight months already.

Secretly, she packed her normal clothes in a backpack, changed wherever she could before entering school, then changed back again before her father came to pick her up.

After school one day, a teacher and some students spotted her behind a bush pulling on her princess outfit.

"I'm in an Easter play for church," she lied — Easter being a week gone already.

The teacher folded her arms and furrowed her brow, so Sarah invited her to the performance, promising to bring a flyer next week, before running off to her father's new sports car.

Later that night, after agreeing to play the newest Atari game her father brought home, she told him that the school wouldn't allow her to wear the dress anymore.

He became angry for a moment and his eyes glazed over, allowing an asteroid to destroy his ship. Then he relaxed and sad, "Yes, it's probably better, we wouldn't want to make the other children jealous."

All Over Coffee

All the books have been rearranged, this time by color, music by clarity.

She hasn't left the flat for three days.

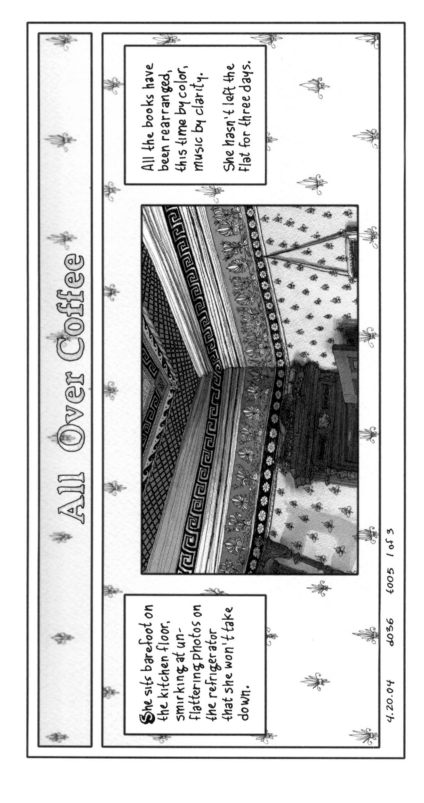

She sits barefoot on the kitchen floor, smirking at un-flattering photos on the refrigerator that she won't take down.

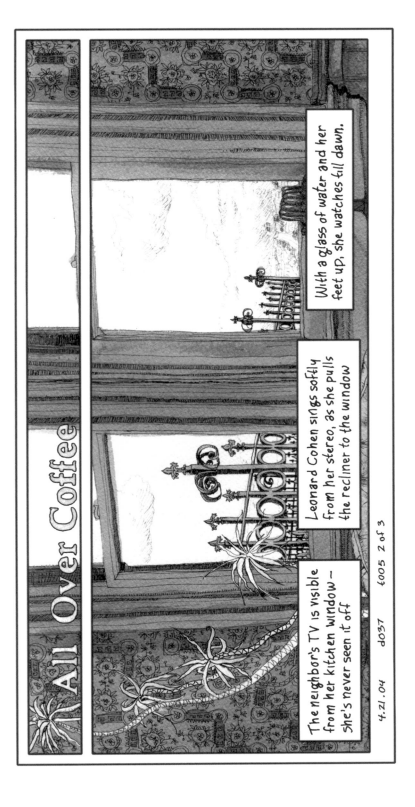

The neighbor's TV is visible from her kitchen window — She's never seen it off

Leonard Cohen sings softly from her stereo, as she pulls the recliner to the window

With a glass of water and her feet up, she watches till dawn.

4.21.04 d057 £005 2 of 3

All Over Coffee

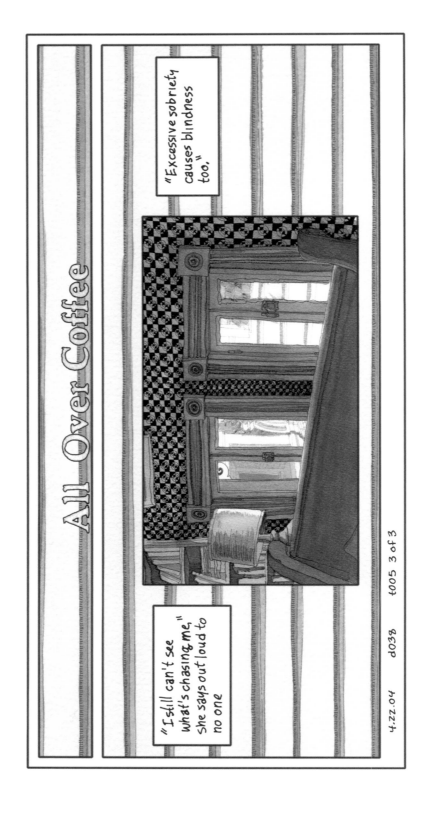

"Excessive sobriety causes blindness too,"

"I still can't see what's chasing me," she says out loud to no one

All Over Coffee

The man at the table in front of me snaps his newspaper every time he turns a page

As if stretching a giant spring, he sticks out his elbows, crowding the people on both sides of him

He sneezes, then reflexively says
— to himself —
"God bless you"

Leaning in close to the man on his right, he scans the room to ensure no one is listening

"What bothers me," he confides, "is had I known before I got hitched that gay marriage might be legal,

I wouldn't have ruled out an entire gender."

4.25.04

All Over Coffee

"On the bus today," he said, "I caught a reflection of myself in the window, and thought, *that's* the expression my face will be frozen in when I'm old."

"But the sun was in my eyes, and I was squinting,

So it may not be true."

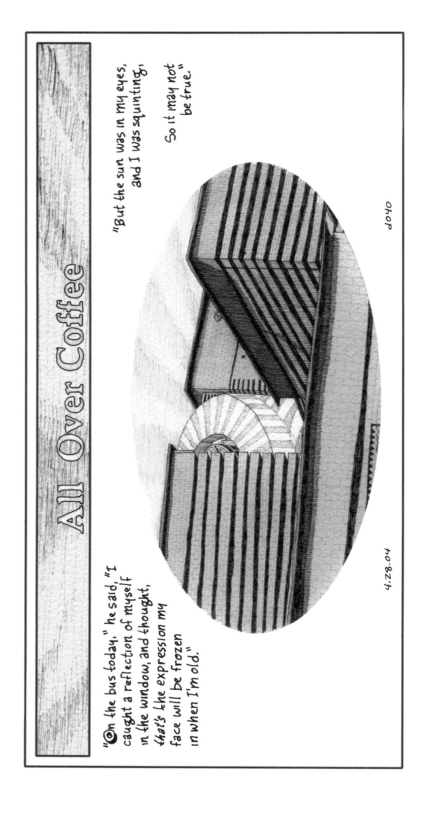

4.28.04

ohop

All Over Coffee

A man wearing a foam baseball cap brushes off a used coffee cup he pulled from the trash, then heads to the counter for a cheap refill

"I hope I'm still around when a woman is president," he says to anyone off guard enough to acknowledge him

"Women always liked me."

5.4.04 d042

All Over Coffee

Everything takes more time, money, and effort than you think it will

Plus something you could never imagine, until you're completely immersed.

5.5.04 d043

All Over Coffee

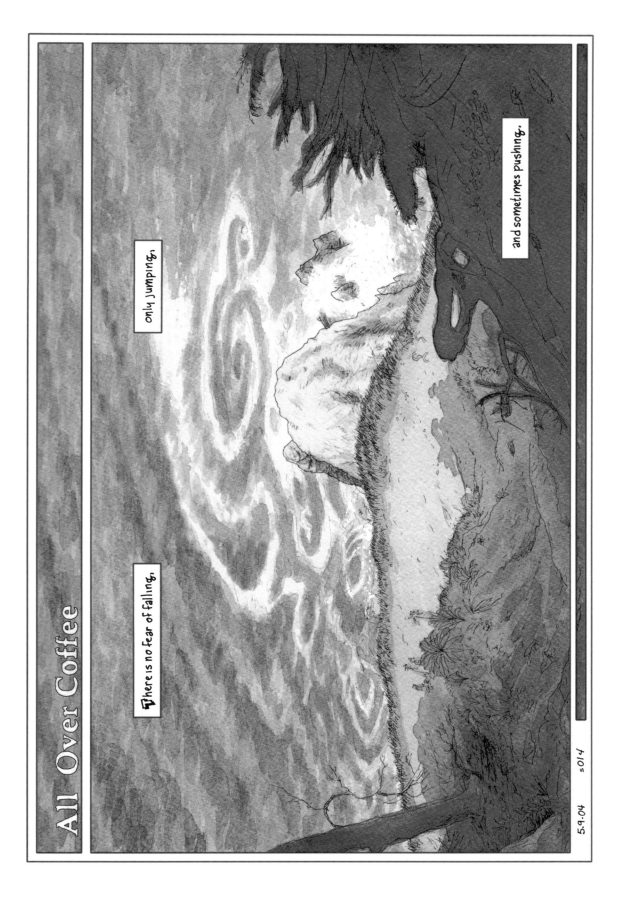

There is no fear of falling,

only jumping,

and sometimes pushing.

All Over Coffee

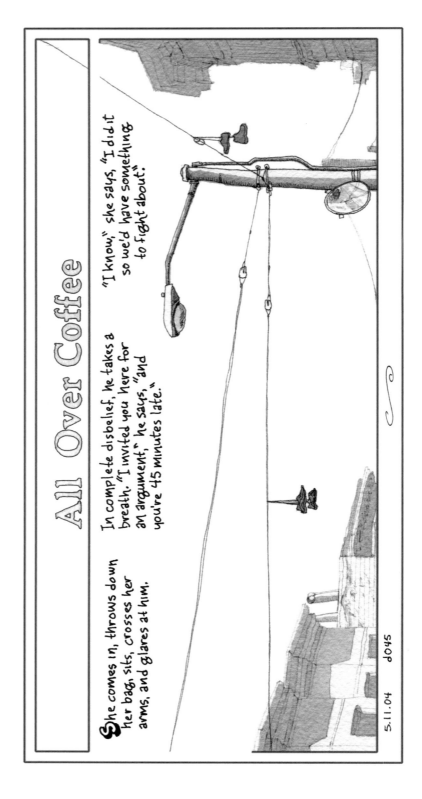

She comes in, throws down her bag, sits, crosses her arms, and glares at him.

In complete disbelief, he takes a breath. "I invited you here for an argument," he says, "and you're 45 minutes late."

"I know," she says, "I did it so we'd have something to fight about."

All Over Coffee

I thought the best way to keep
people out of my business
was to stay out of theirs

But they broke all my windows
just to have a look

Now I'm open for all the world to see

And they avoid me like debt.

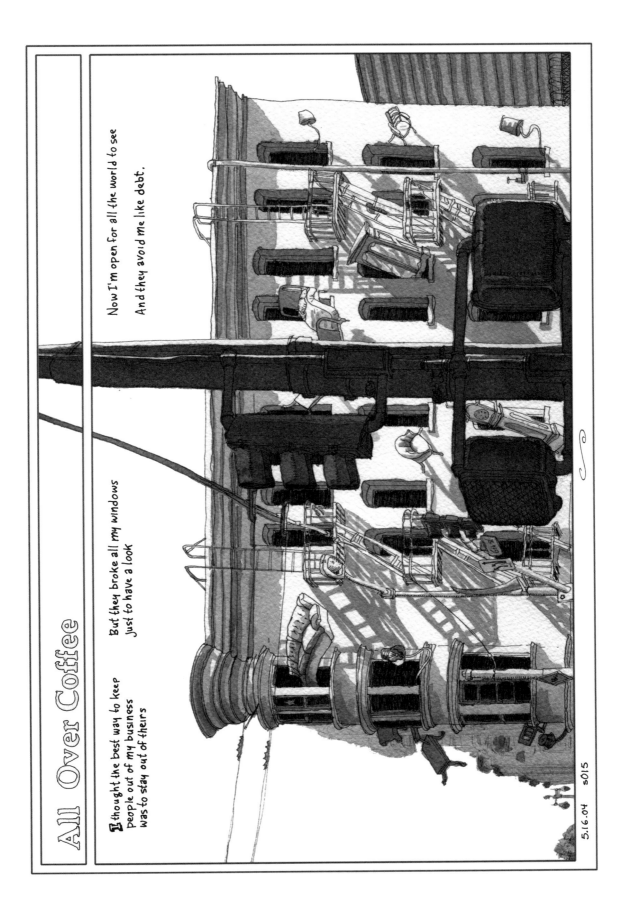

All Over Coffee

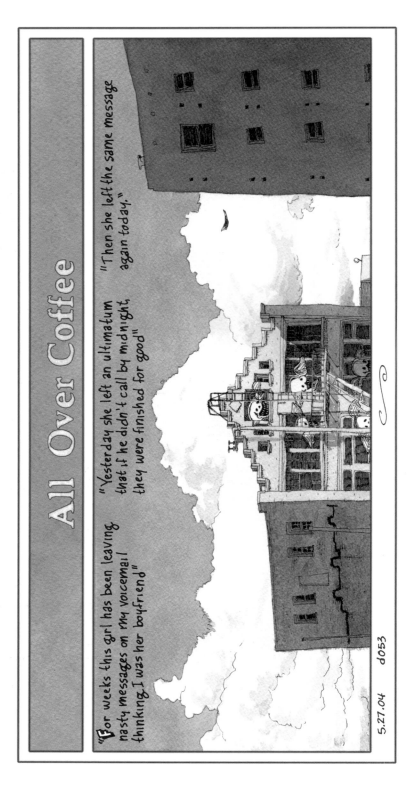

"For weeks this girl has been leaving nasty messages on my voicemail thinking I was her boyfriend"

"Yesterday she left an ultimatum that if he didn't call by midnight, they were finished for good"

"Then she left the same message again today."

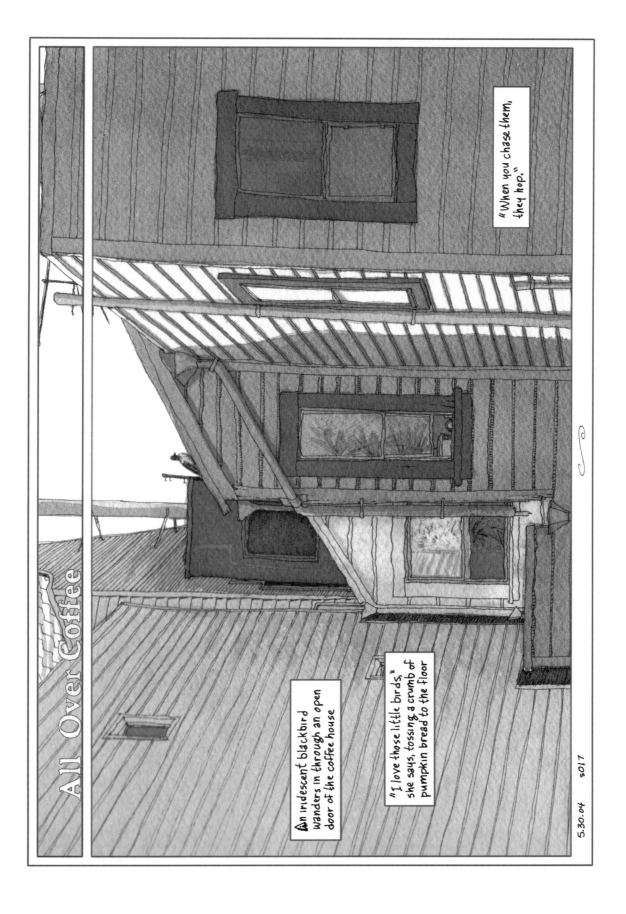

All Over Coffee

An iridescent blackbird wanders in through an open door of the coffee house

"I love those little birds," she says, tossing a crumb of pumpkin bread to the floor

"When you chase them, they hop."

All Over Coffee

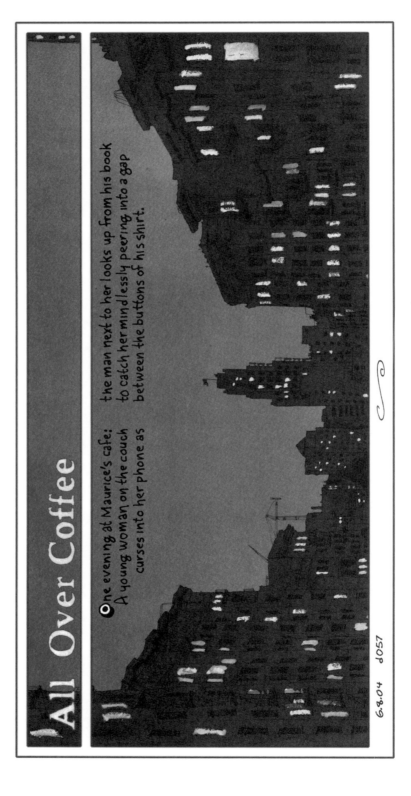

One evening at Maurice's cafe:
A young woman on the couch
curses into her phone as

the man next to her looks up from his book
to catch her mindlessly peering into a gap
between the buttons of his shirt.

6.8.04 d057

All Over Coffee

Maurice waits for the taqueria restroom.
A security guard walks by.
"You been here long?" he asks.
"No, just a minute."

A man comes up behind, forms a line.
After a few minutes the restroom is vacated.
As Maurice starts to enter,
he notices the man behind him is sweating.
"You can go ahead of me," Maurice offers,
and the man rushes in without polite refusal.

The security guard returns.
"You still waiting?" he says, then, without allowing
Maurice to answer, he raps on the door and walks on.
A moment later the restroom door opens, the man smiles,
presses himself against the wall, and gestures grandly for
Maurice to enter.

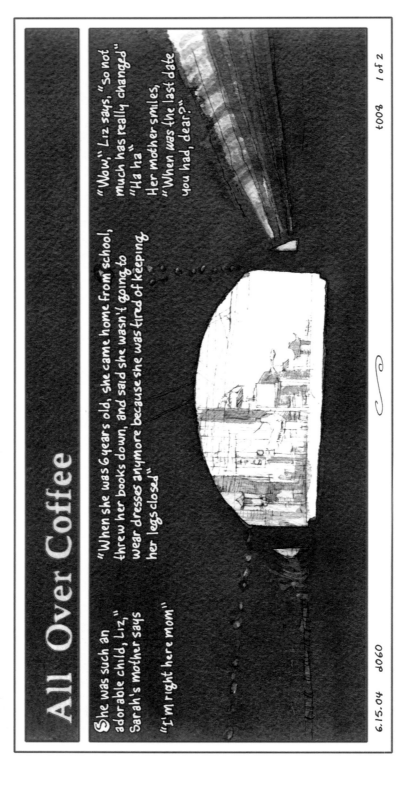

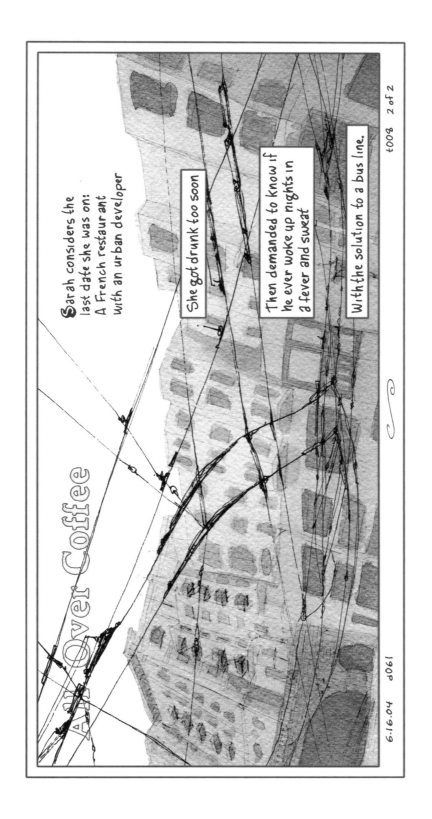

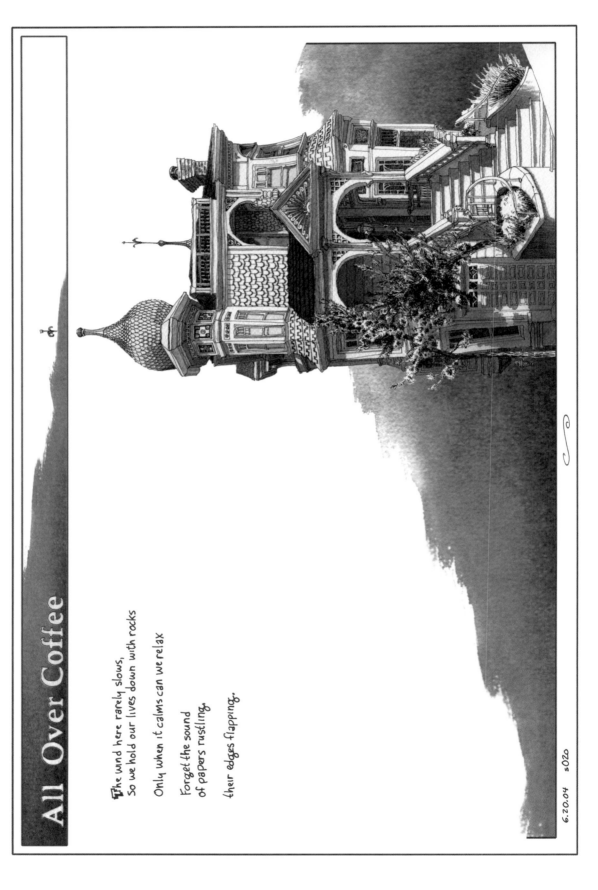

All Over Coffee

The wind here rarely slows,
So we hold our lives down with rocks

Only when it calms can we relax

Forget the sound
of papers rustling,

their edges flapping.

6.20.04 s020

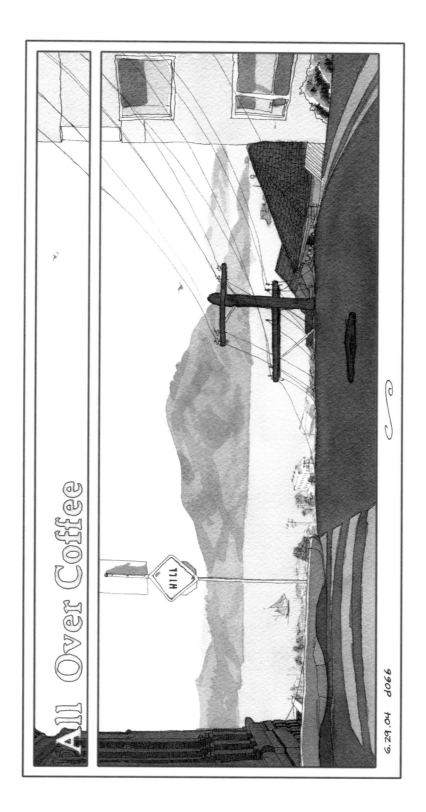

All Over Coffee

HILL

6.29.04 P066

All Over Coffee

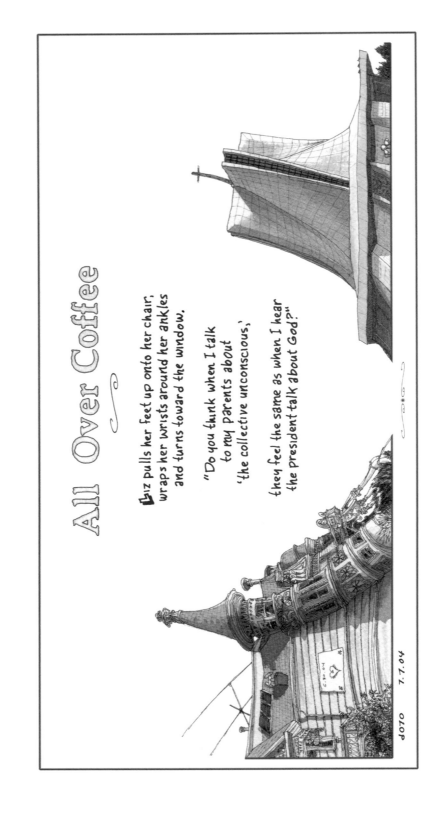

Liz pulls her feet up onto her chair,
wraps her wrists around her ankles
and turns toward the window.

"Do you think when I talk
to my parents about
'the collective unconscious,'

they feel the same as when I hear
the president talk about God?"

7.7.04

0070

All Over Coffee

"Hey"
"Hey, what happened to you last night?"
"I was going to ask you the same thing"
"What are you talking about? I was there at 10 sharp"
"I left at quarter till"
"Why'd you do that? You told me to meet you there at 10"

"I meant I'd be there until 10"
"But you said meet"
"Well that's not what I meant"
"But that's what you said"
"It's not a big deal, it was just a misunderstanding"
"No, it was a miscommunication, not a misunderstanding"
"Why do you always do this?"
"Because there was no misunderstanding, I understood just fine"
"Well obviously you didn't."

65

All Over Coffee

"Honey! You can't say that!"
"What? Oh yeah, I forgot,

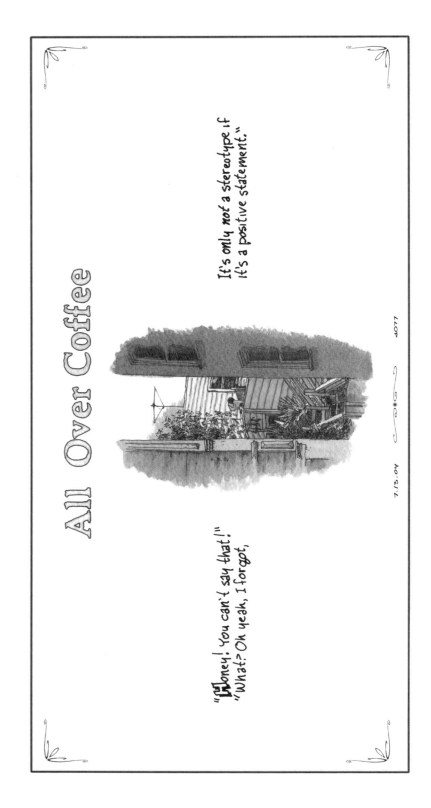

It's only *not* a stereotype if
it's a positive statement."

7.15.04 4077

All Over Coffee

A woman slumps over the pages of a textbook. "I wish I had someone to talk to," she sighs.

The man on the couch with a pen clipped to his lip perks up and smiles.

"Hello," he says with a shake of the head.

The woman turns to him, eyes wide, and stares.

"I was wrong," she says, then goes back to her book.

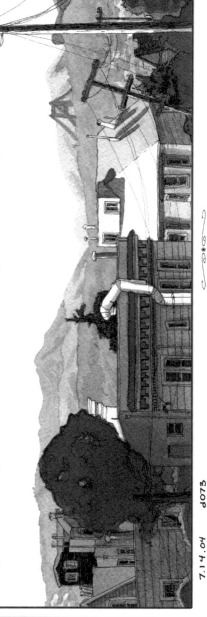

7.14.04 d073

All Over Coffee

"No, no, put your fingers together with your thumbs up, that's it."

"Really? Then the goal's huge."

"Them's the rules, can I help it if you have bony fingers?"

Sarah steadies a foil-wrapped single serving of butter on one corner and lines up a shot, "Ewww, it's soft," she says, then flicks the object toward Liz.

Splatters of oil hit the table as the disfigured cube flies over Liz's shoulder, landing on the counter in front of Maurice.

Maurice comes over shaking his head, "Ladies, am I going to have to ask you to leave?"

Sarah looks up and grins, "We're playing a butter-table-football championship to see who gets to beat you into submission for playing such awful music."

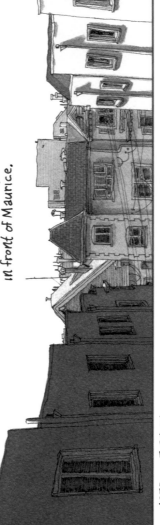

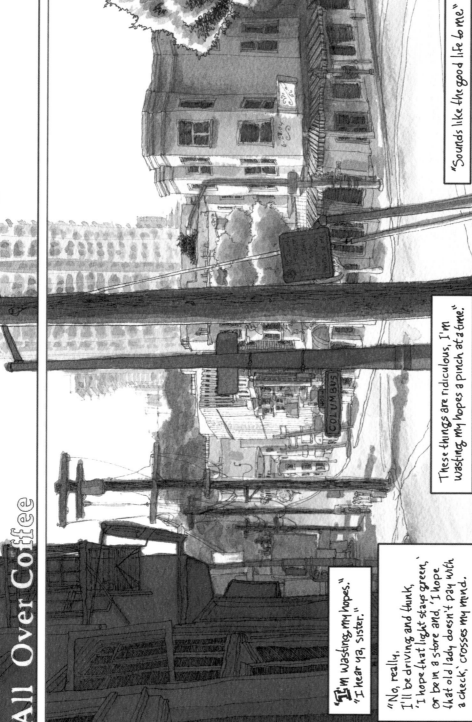

All Over Coffee

"I'M wasting my hopes."
"I hear ya, sister."

"No, really,
I'll be driving and think,
'I hope that light stays green,'
or be in a store and, 'I hope
that old lady doesn't pay with
a check,' crosses my mind.

These things are ridiculous, I'm
wasting my hopes a pinch at time."

"Sounds like the good life to me"

7.25.04 #025

69

All Over Coffee

"I'm sick of spending so much time talking about nothing"

"But you talk about so little"

"Fine, then so much time listening to nothing"

"Maybe you should talk more"

"Maybe I should just stay home."

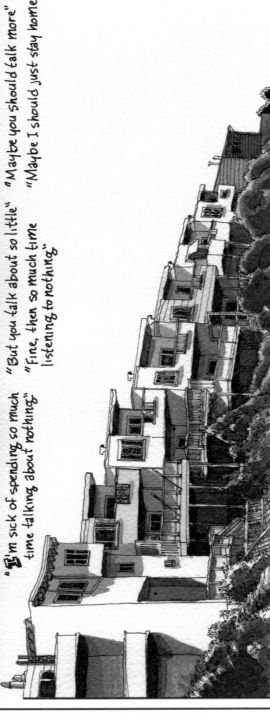

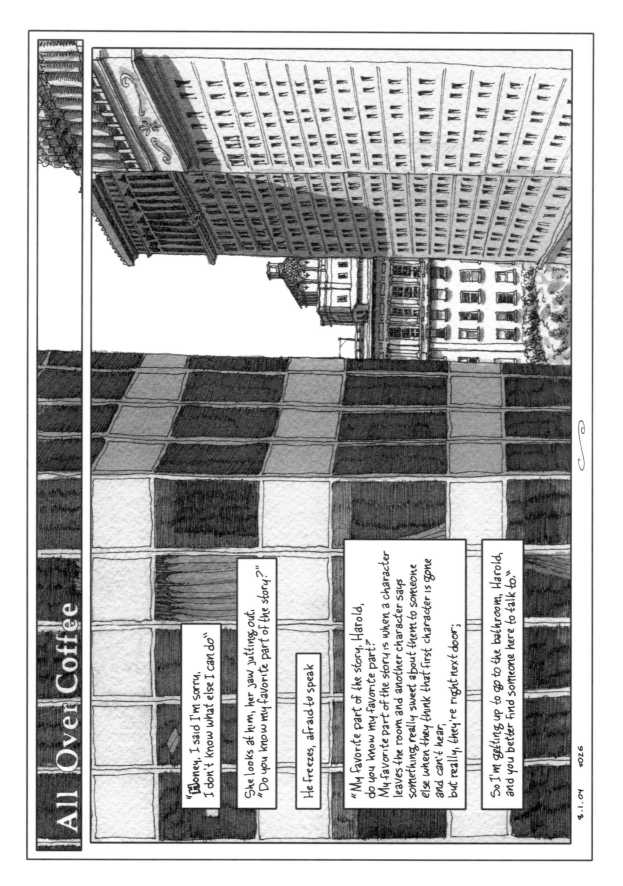

All Over Coffee

"Honey, I said I'm sorry,
I don't know what else I can do"

She looks at him, her jaw jutting out.
"Do you know my favorite part of the story?"

He freezes, afraid to speak

"My favorite part of the story, Harold,
do you know my favorite part?
My favorite part of the story is when a character
leaves the room and another character says
something really sweet about them to someone
else when they think that first character is gone
and can't hear,
but really, they're right next door;

So I'm getting up to go to the bathroom, Harold,
and you better find someone here to talk to."

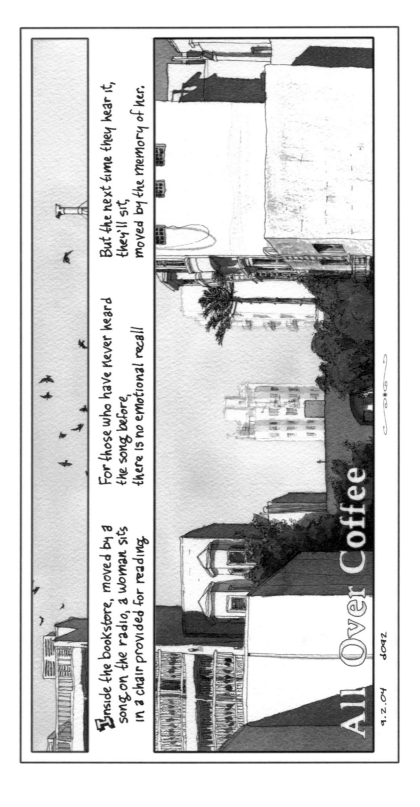

Inside the bookstore, moved by a song on the radio, a woman sits in a chair provided for reading.

For those who have never heard the song before, there is no emotional recall.

But the next time they hear it, they'll sit, moved by the memory of her.

All Over Coffee

9.2.04

doaz

All Over Coffee

Sarah wanted to see something seedy.

She sat in the dark for hours, scanning windows.

Eventually a man appeared in a room across the street. Sarah ducked, though there was no way he could have seen her.

She held her breath and watched as the man paced around the room in his robe, a sleeping baby on his shoulder.

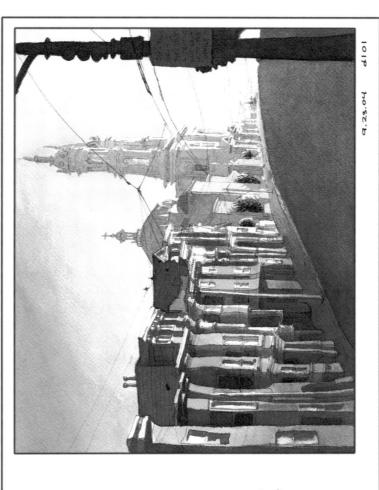

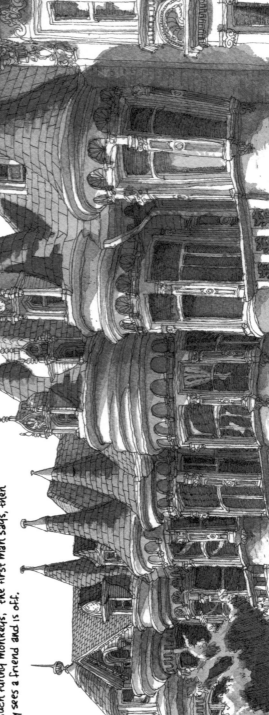

All Over Coffee

A man approaches two people on a couch in a crowded cafe.
"You mind if I sit here?" he asks.
"No, go ahead," the man in the middle says, removing scattered newspaper from the spot next to him.
The woman on his other side scoots toward her armrest and looks up from her book to smile in acknowledgment of the situation.
"Thank you," the first man says, taking the seat.
He sits with his shoulders hunched, then sighs. "These situations are so awkward, aren't they?" he says to the man in the middle.
"Yeah," the man responds politely, then returns to his newspaper.
"I was just saying to a friend the other day how it's funny that in the country you can be miles away from your neighbors but still know them intimately, whereas in cities you can go years without even talking to the person right next door to you."
The man in the middle smiles tightly, barely responding.
"We're such funny monkeys," the first man says, then suddenly sees a friend and is off.

The middle man slides over, eliminating the vacant spot; he and the woman look at each other with a smile of relief.
"I hate that," he says.
"I know," she says with a breath of laughter, then they both return to reading.

After a moment he turns to her. She senses his attention but doesn't look up.
"My mother is that kind of person," he says, "used to drive my father crazy, we'd be out somewhere and she'd start talking to anyone within arm's reach, got to be where..."

9.19.04 s052

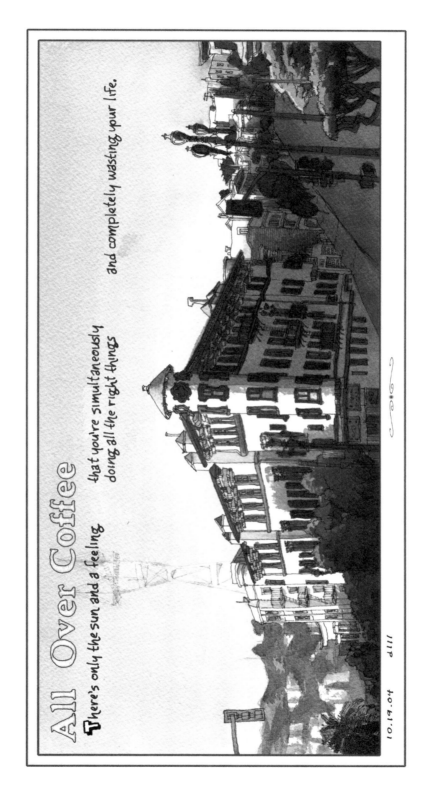

All Over Coffee

There's only the sun and a feeling that you're simultaneously and completely wasting your life.
doing all the right things

711P

10.91.04

75

All Over Coffee

How she landed in a culture of people who spend most of their time holding their pants up still escapes her

It's these sorts of mysteries — finding yourself in places you would never choose — that seem stuck beyond awareness, and frighten her about freedom.

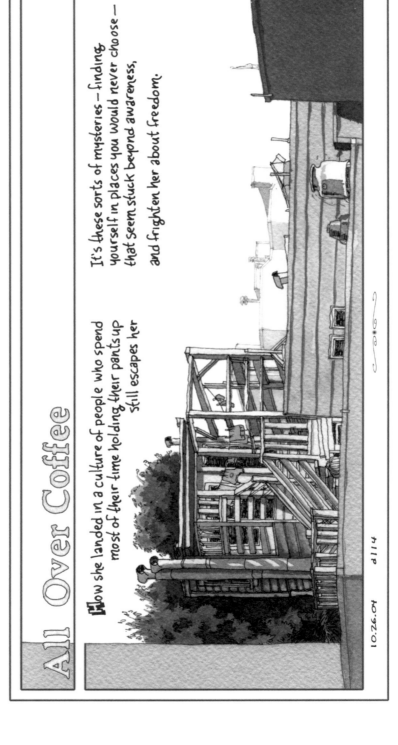

10.26.04

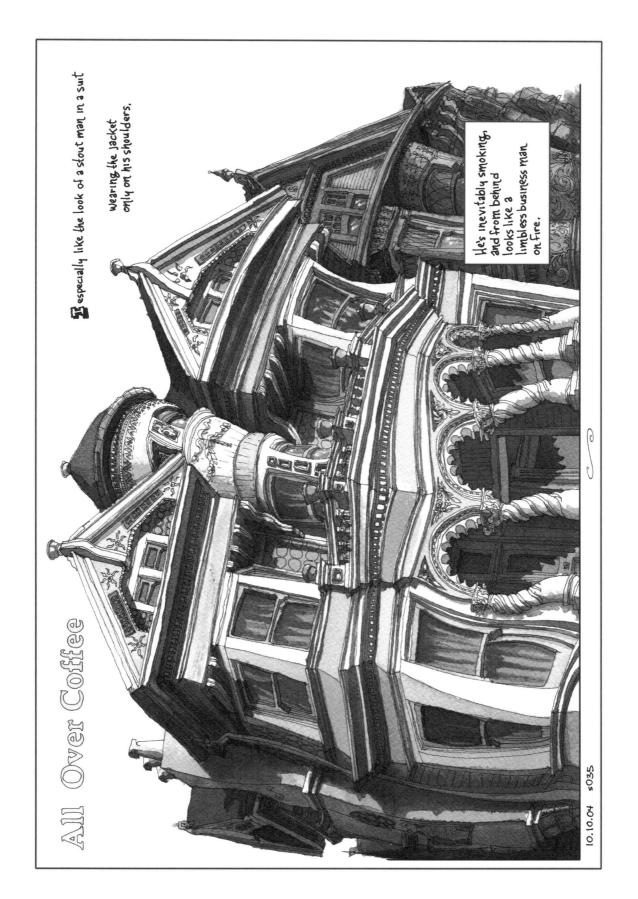

All Over Coffee

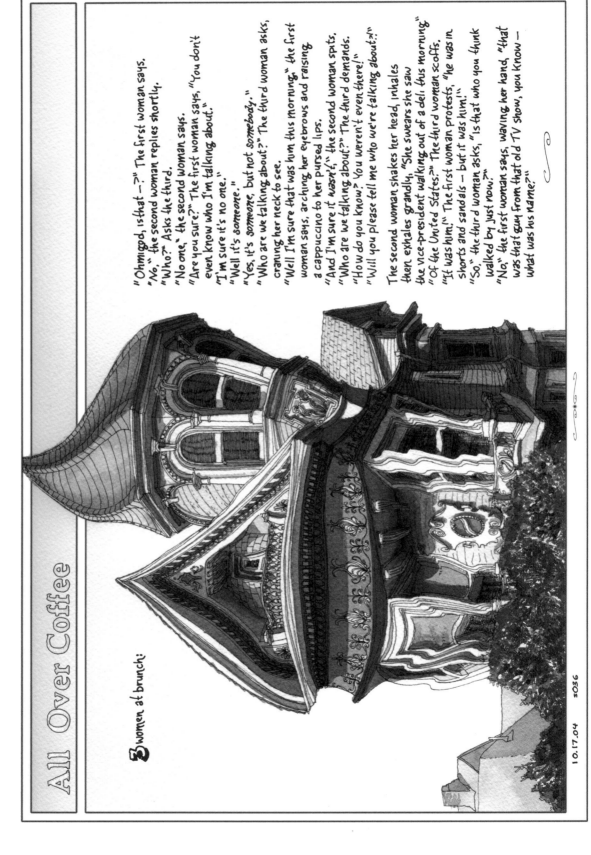

3 women at brunch:

"Ohmigod, is that —?" The first woman says.

"No," the second woman replies shortly.

"Who?" Asks the third.

"No one," the second woman says.

"Are you sure?" The first woman says, "You don't even know who I'm talking about."

"I'm sure it's no one."

"Well it's someone."

"Yes, it's someone, but not somebody."

"Who are we talking about?" The third woman asks, craning her neck to see.

"Well I'm sure that was him this morning," the first woman says, arching her eyebrows and raising a cappuccino to her pursed lips.

"And I'm sure it wasn't," the second woman spits.

"Who are we talking about?" The third demands.

"How do you know? You weren't even there!"

"Will you please tell me who we're talking about?"

The second woman shakes her head, inhales then exhales grandly, "She swears she saw the vice-president walking out of a deli this morning."

"Of the United States?" The third woman scoffs.

"It was him," The first woman protests, "he was in shorts and sandals — but it was him."

"So," the third woman asks, "is that who you think walked by just now?"

"No," the first woman says, waving her hand, "that was that guy from that old TV show, you know — what was his name?"

All Over Coffee

"So what are you doing for halloween?" A woman asks her friend.

"I don't know, probably nothing."
"Oh! I almost forgot, you're not going to believe what happened the other day —

I was walking down the street and accidentally dialed John's number."
"Oh my God."

"I know, I haven't seen him since we split, like, three years ago, and you remember, it was pretty bad."

"You could say that."

"Well I had no idea that's who I called until he answered.
We started talking, and next thing I know there he is, right in front of me on the sidewalk! Turns out he was moving to New York and had just stopped to do the final check on his apartment."

"That's crazy!"

"I know! He invited me in. The place was totally empty so we stood in the kitchen eating from a bag of stale candy corns that he said had been there since he moved in.

We totally caught up but then we both had to go, so we hugged and said goodbye.

It was really great to see him, and after I felt light, like some invisible weight had just been lifted."

"Wow," her friend says, "What a story — makes sense though,
ghosts come out on halloween."

10.31.04 s036

79

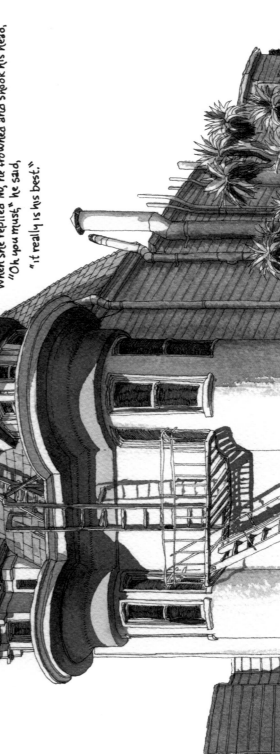

All Over Coffee

"There is no evil, only fear and isolation."
This is the line she quoted lately.
"It's from the book 'Scared to Death',
by Emit Hopper," she'd say,
and people would nod in agreement.

The book didn't exist,
though,
nor the author.

The line was hers.

She had found that when people offered their opinion
on something she had written, they took the high ground,
debating the words, rather than considering the idea.
So she fictionalized a reference,
which instantly validated the subject.

"Yes, yes, I know him well," one man cooed, "In fact,
I believe the line is actually:
'No true evil exists, there is only fear and isolation.'"
Corrections were always longer than her version.
"Have you read 'The Quiet Room'?" he continued,
touching her arm.
It was rare for someone to cite the author's other works.
When she replied No, he frowned and shook his head,
"Oh you must," he said,

"it really is his best."

All Over Coffee

Last night I was an asshole. Out of nowhere I felt like starting a fight, and did for no other reason.

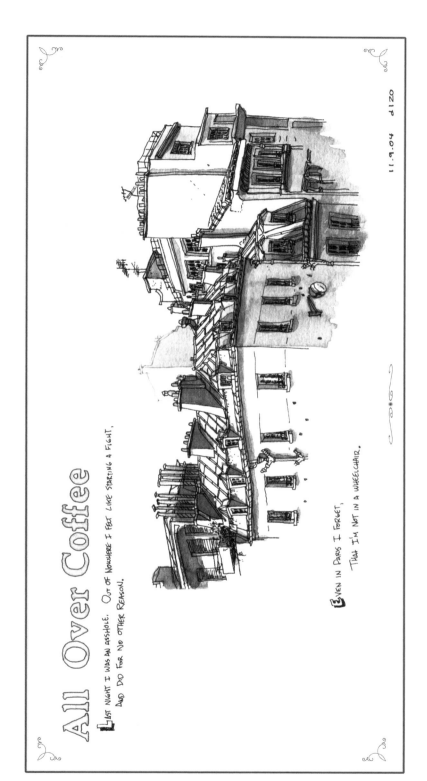

Even in Paris I forget, that I'm not in a wheelchair.

P120 04.9.11

All Over Coffee

The hardest times become the fondest in memory, a mechanism to believe we've learned something.

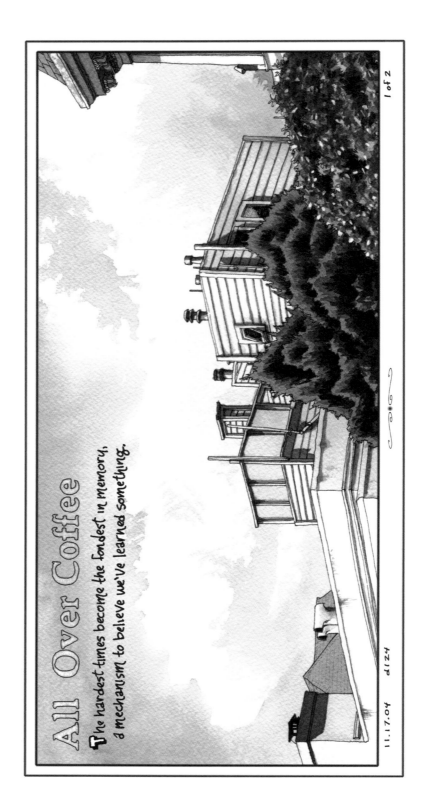

All Over Coffee

We rewrite the past each time we revisit it,

choosing which events are significant based on what we now believe is important.

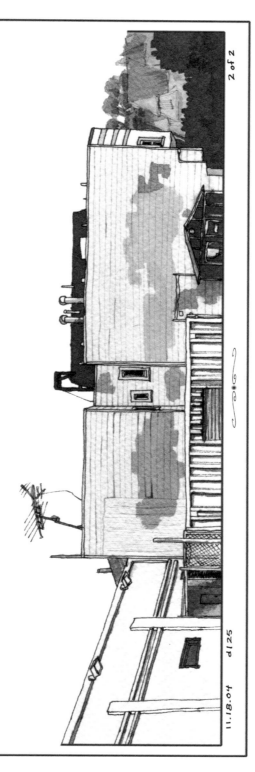

11.18.04 d125

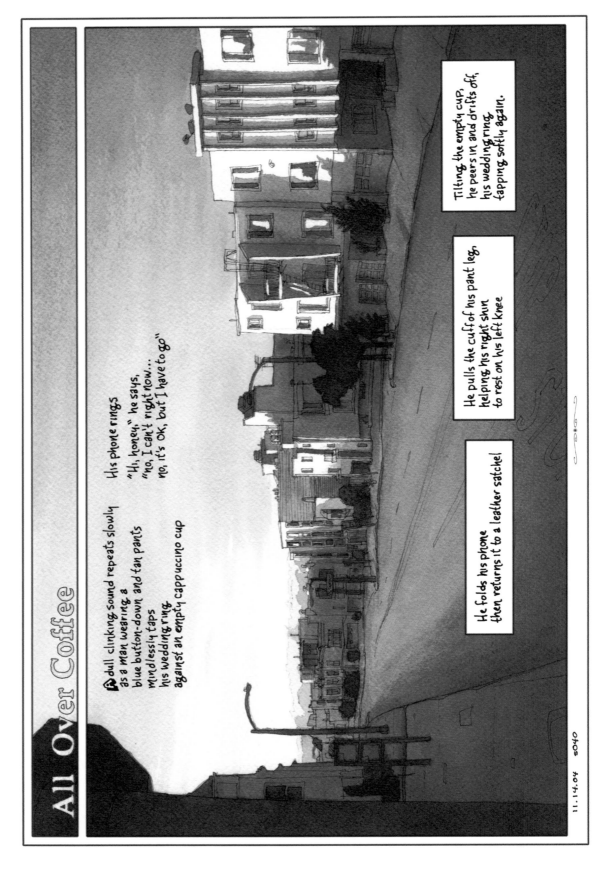

All Over Coffee

A dull clinking sound repeats slowly
as a man wearing a
blue button-down and tan pants
mindlessly taps
his wedding ring
against an empty cappuccino cup

His phone rings

"Hi, honey," he says,
"no, I can't right now...
no, it's OK, but I have to go"

He folds his phone
then returns it to a leather satchel

He pulls the cuff of his pant leg,
helping his right shin
to rest on his left knee

Tilting the empty cup,
he peers in and drifts off,
his wedding ring
tapping softly again.

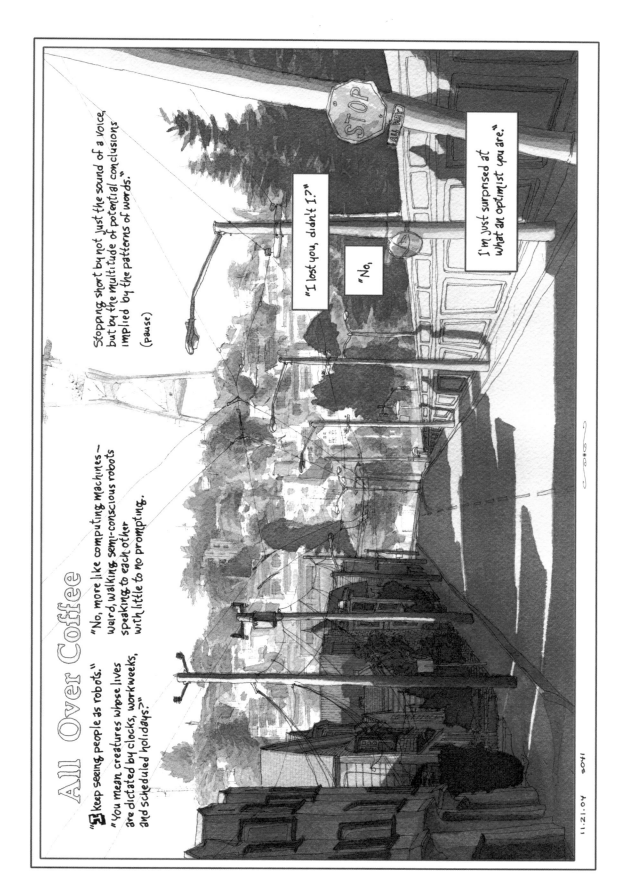

All Over Coffee

Life is just a series of problems.

Problems she can't imagine bothering anyone with.

All Over Coffee

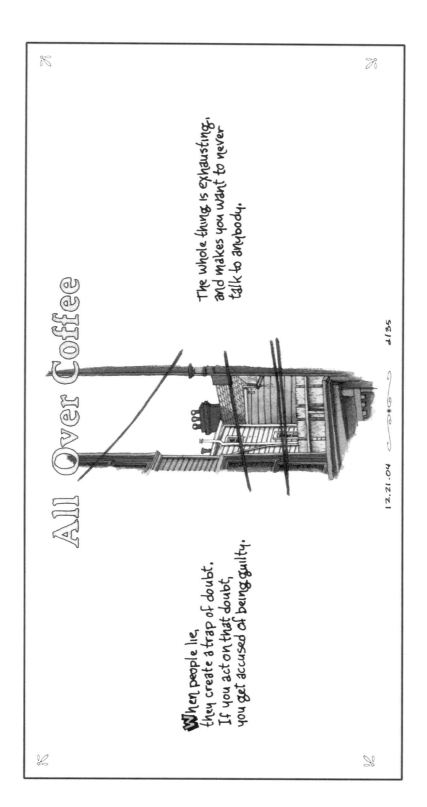

The whole thing is exhausting, and makes you want to never talk to anybody.

When people lie, they create a trap of doubt. If you act on that doubt, you get accused of being guilty.

12.21.04 SF35

All Over Coffee

Between an afternoon appointment and retrieving his daughter from her nanny, M went to Klaus's deli for his favorite lunch.

Standing in line, he saw a handwritten sign taped to the wall:
"Several muggings have occurred at the mini park at Connecticut and 22nd Avenue, be aware when walking in that area."

Eating a Rudolph sandwich (crab salad on french roll — his without pickle and mayo), M considered how only a few years ago, that sign would have meant little to him. Penniless, his clothes ragged, he would have strolled through that park confident no mugger would want anything on him.

But M had changed; today, he wouldn't go near that park. This troubled him, and he knew why: now he had something to lose.

This realization clung to M's mind all day, into the night and throughout the week.

By being afraid to walk in a park — a mini park — in broad daylight, he felt he had given something up.

Surely something valuable in him had been lost, slowly and unknowingly, the way all important things erode, to rise to this stature of having something to lose.

After two weeks of sleepless nights, M lay awake, certain he had been robbed.

Slipping out of bed, he phoned his office, leaving his resignation on voice mail. Then, gathering only what would fit in a small bag, he left his wife, child and home.

Wearing a faded pullover of his alma mater, and shivering under a clear December sky, M headed to the end of Connecticut Avenue,

to go for a walk in the park.

All Over Coffee

An Unfinished Scene from Paris:

"I've always said that in order to lead the life you want, you need to start living it," she said, sitting up in bed.

She wasn't wearing any clothes.

Staring out the window, she added, "If I won't just come to you."

"I don't think the hotel will be very pleased that we moved the furniture," he said, coming out of the bathroom, wiping his hands against his bare thighs.

"What time is it?" she asked.

"2pm."

"Hmmm..." she said, still not looking at him, "maybe now we can get some breakfast."

"Breakfast was hours ago," he laughed, rubbing his head with a towel.

"Then maybe we should go to another country," she said, turning to him defiantly, "there's only so much bread, chocolate and cheese a person can eat."

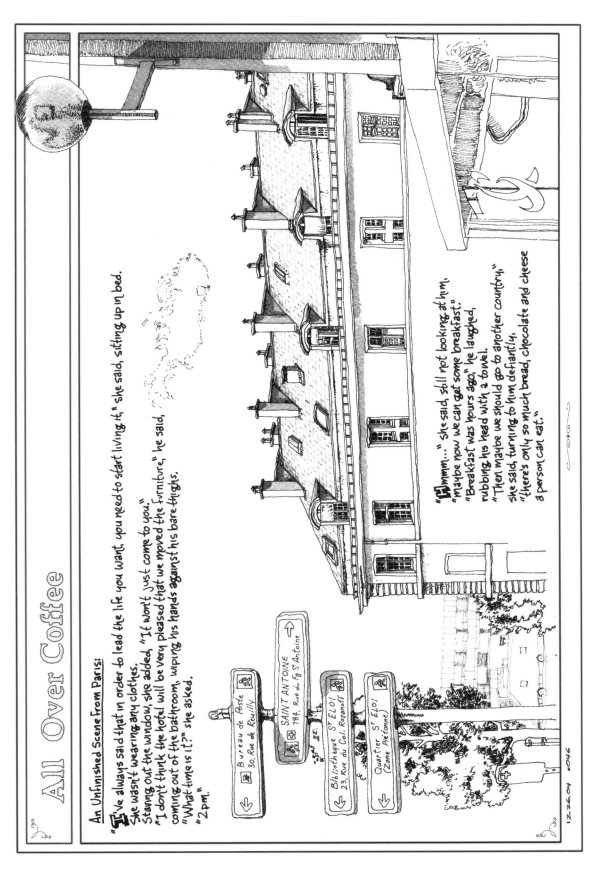

12.26.04 #046

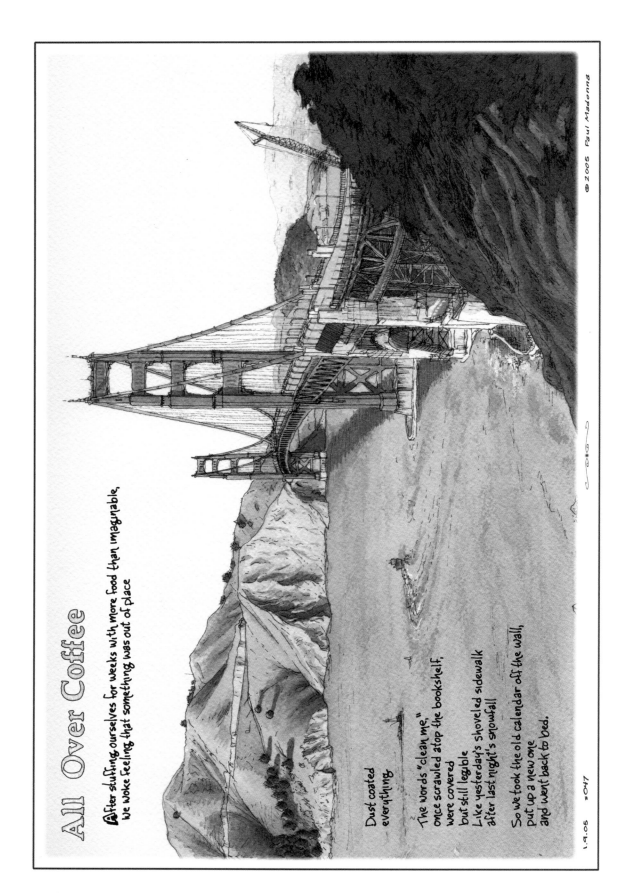

All Over Coffee

After stuffing ourselves for weeks with more food than imaginable, we woke feeling that something was out of place

Dust coated
everything

The words "clean me,"
once scrawled atop the bookshelf,
were covered
but still legible
Like yesterday's shoveled sidewalk
after last night's snowfall

So we took the old calendar off the wall,
put up a new one
and went back to bed.

All Over Coffee

She thinks of friends and lies,
that sometimes we must concede
to something outside of ourselves

to remember
that the world doesn't always agree
with our sense of justice.

ship 1.15.05

All Over Coffee

Marlene considers becoming a writer, but she never writes.

Philosophy interests her.
Her grandfather studied philosophy, and he'd probably forgive everything if she took it up. But at some point, he turned into a holy roller, and if that's where that path leads, she wants nothing to do with it.

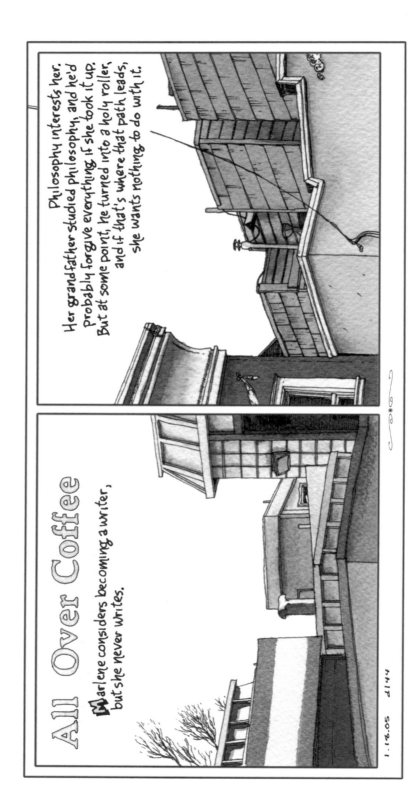

1.8.05

PHP

All Over Coffee

When the artists Andre and Lee married, Andre set out to make a painting to show his love for Lee.

He worked on the same canvas their entire lives, never feeling it was done.

At the end of his days, Andre grew sad before the unfinished work.

"I did not love you enough," he said. "Not true," Lee replied, presenting her husband with a box filled with photos of his canvas.

"I've been taking these, one a week," she said, "for the past forty years."

TRIBUTE TO SEMPÉ

1.30.05 ᴱOSO

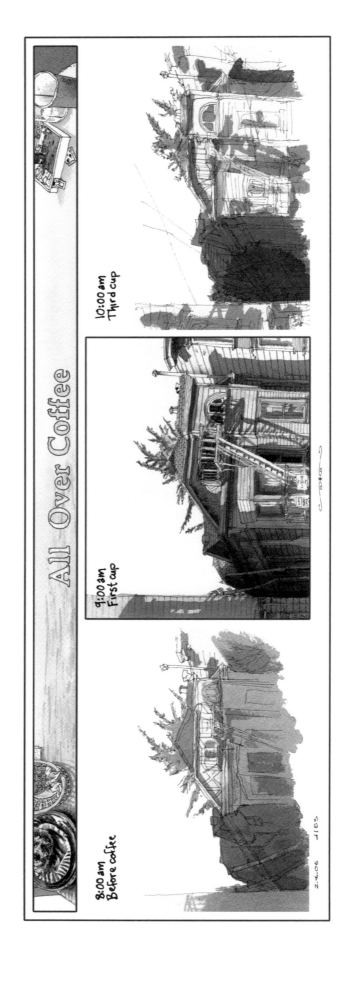

All Over Coffee

There are thousands of people to just after, to fantasize about.

All of whom, she knew, would be impossible to get along with.

Still,

she wanted them.

2.15.05 d155

All Over Coffee

"Have you met his new girlfriend yet?" one woman asks another.
"Yeah, I ran into them here the other morning—she bugged me, but, I don't know, I mean, I'm the ex, so..."
"Let me guess, she totally looked you up and down, right?"
"Oh my God, yes."

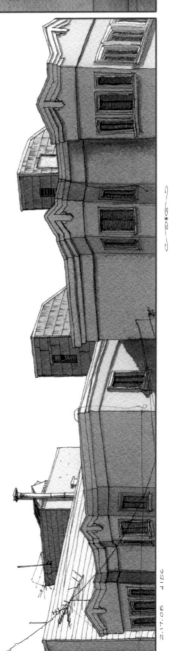

"And not the subtle scan like we all do, but completely obvious, like—" she pulls her head back, sticks out her jaw and slowly scans the other woman from head to toe, then back to head.
"That's it exactly!" the other woman exclaims, and they both burst out laughing.

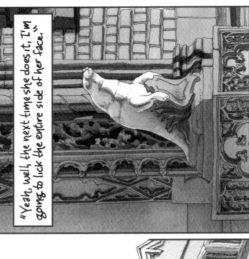

"Yeah, well, the next time she does it, I'm going to lick the entire side of her face."

2.17.05

When asked how she would spend this rainy day, she considered how often she found herself doing the opposite of whatever proclamations she made.

So, rather than state that she would nestle warm and dry in a cafe reading, she replied that she'd brave the buses and puddles and run errands.

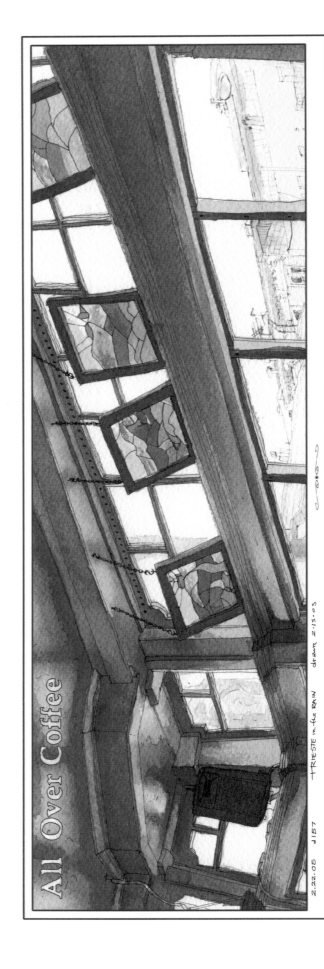

All Over Coffee

2.22.05 J157 TRIESTE in the RAIN drawn 2.15.05

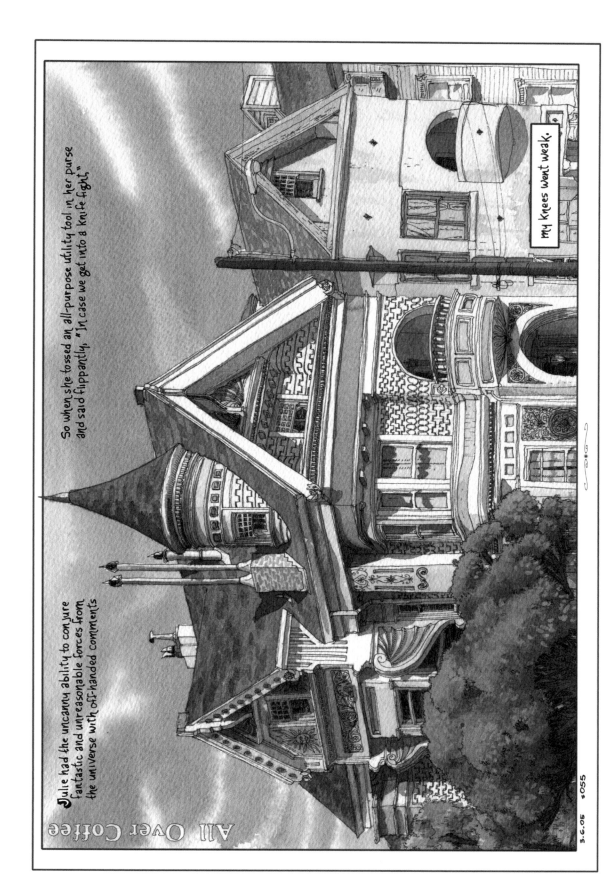

All Over Coffee

Julie had the uncanny ability to conjure fantastic and unreasonable forces from the universe with off-handed comments

So when she tossed an all-purpose utility tool in her purse and said flippantly, "In case we get into a knife fight,"

my knees went weak.

99

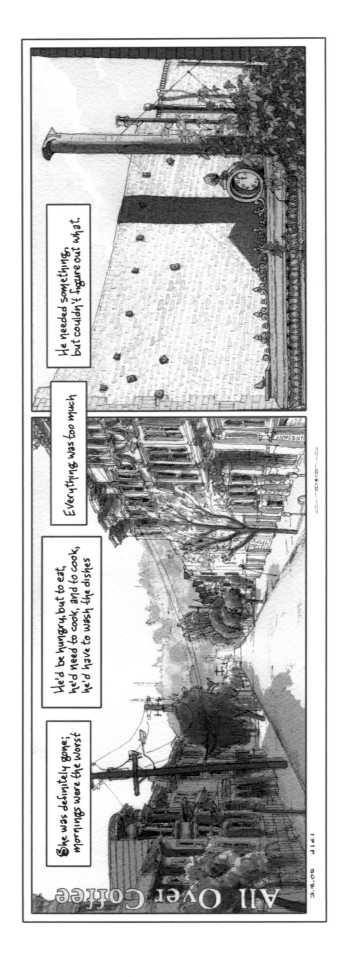

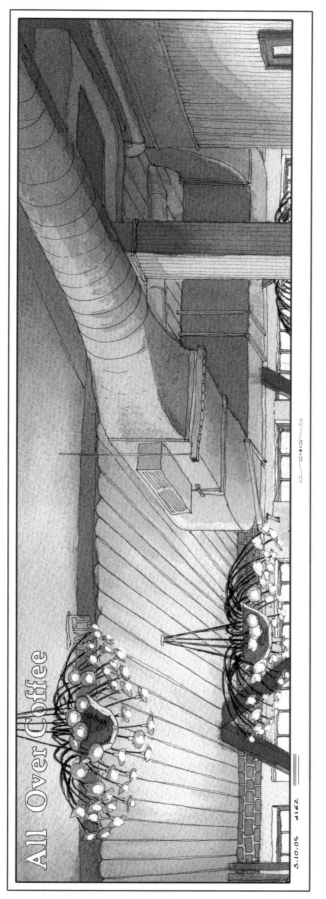

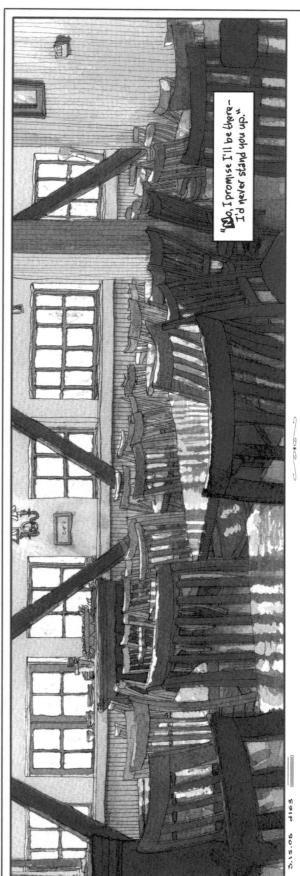

All Over Coffee

We have no idea the demons people face or how they're faring against them.

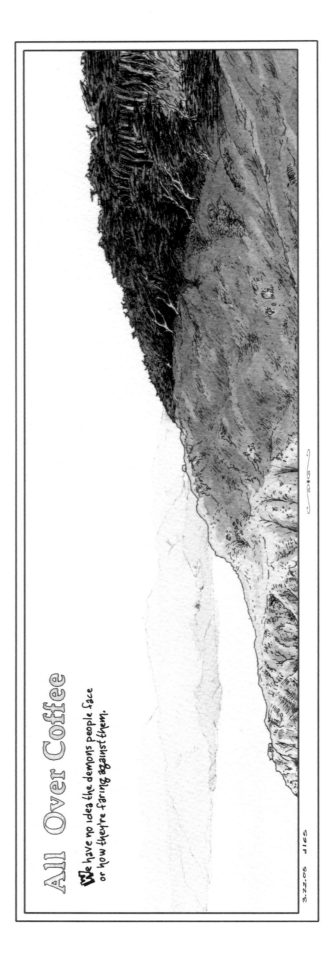

3.22.05 d165

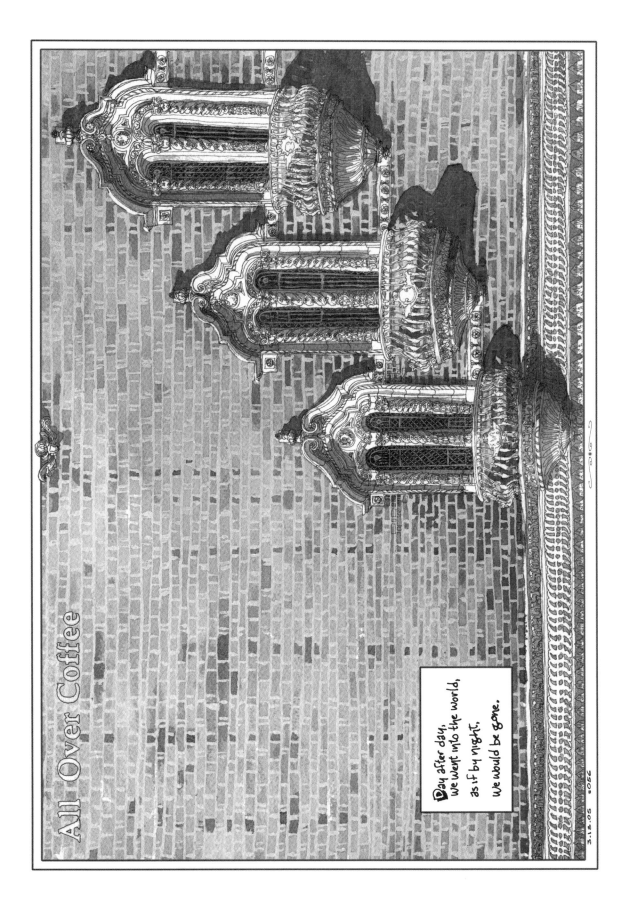

All Over Coffee

Day after day,
we went into the world,
as if by night,
we would be gone.

3.13.05 s056

103

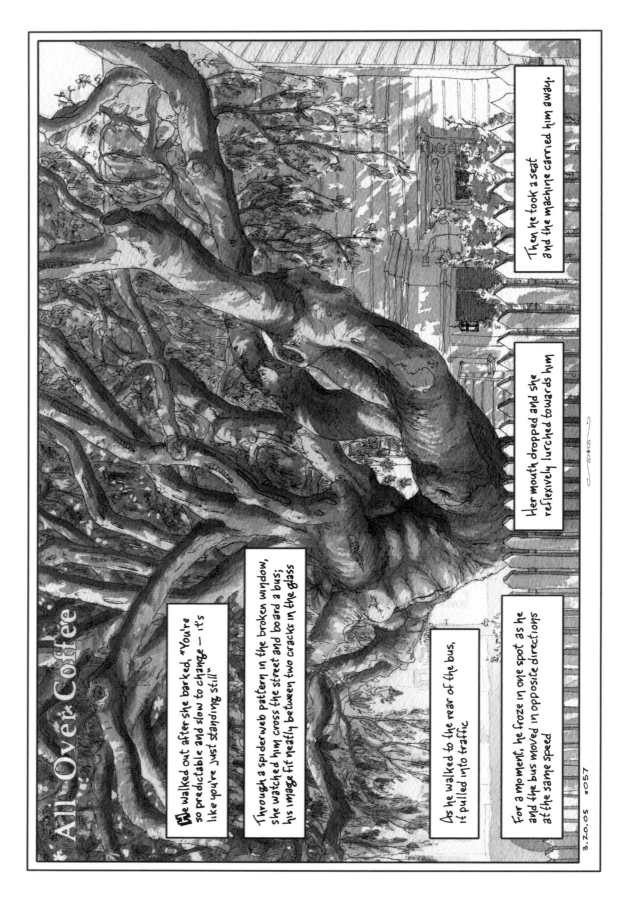

All Over Coffee

She walked out after she barked, "You're so predictable and slow to change — it's like you're just standing still"

Through a spiderweb pattern in the broken window, she watched him cross the street and board a bus; his image fit neatly between two cracks in the glass

As he walked to the rear of the bus, it pulled into traffic

For a moment, he froze in one spot as he and the bus moved in opposite directions at the same speed

Her mouth dropped and she reflexively lurched towards him

Then he took a seat and the machine carried him away.

All Over Coffee

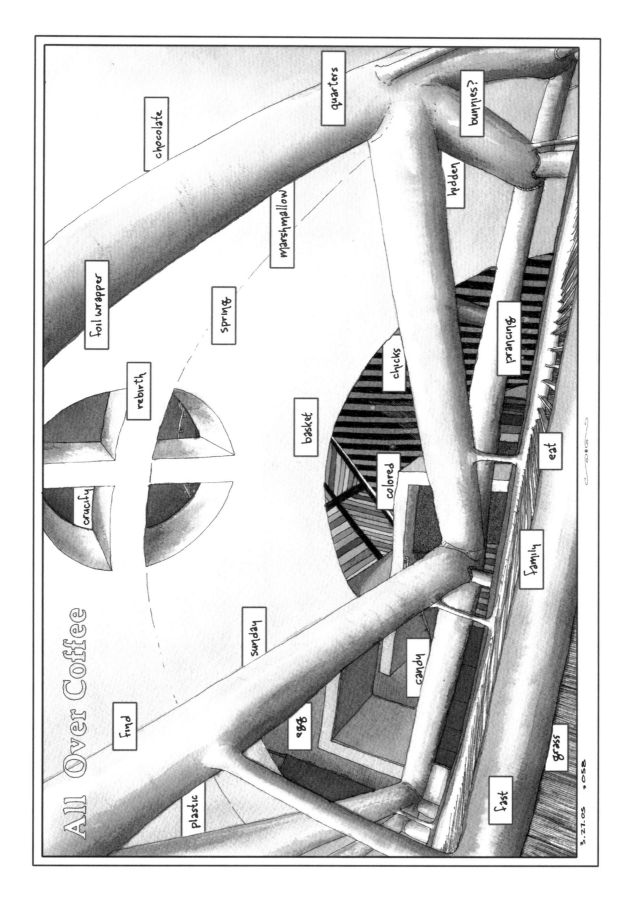

chocolate

quarters

selling

happy

marshmallow

foil wrapper

spring

rebirth

chicks

crucify

basket

coloring

eat

colored

sunday

family

find

candy

egg

grass

plastic

fast

3.21.05 #058

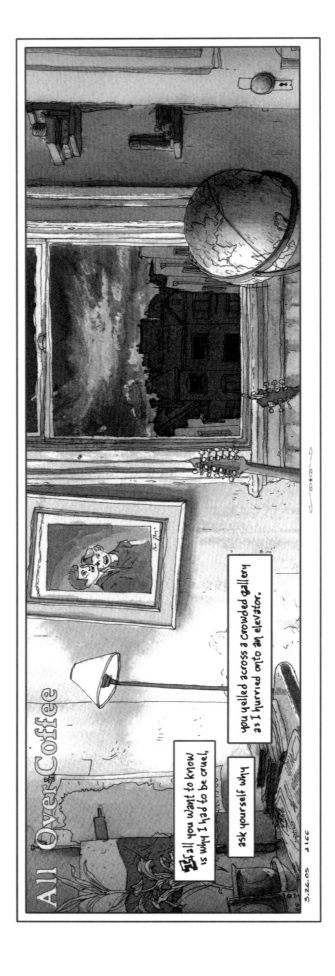

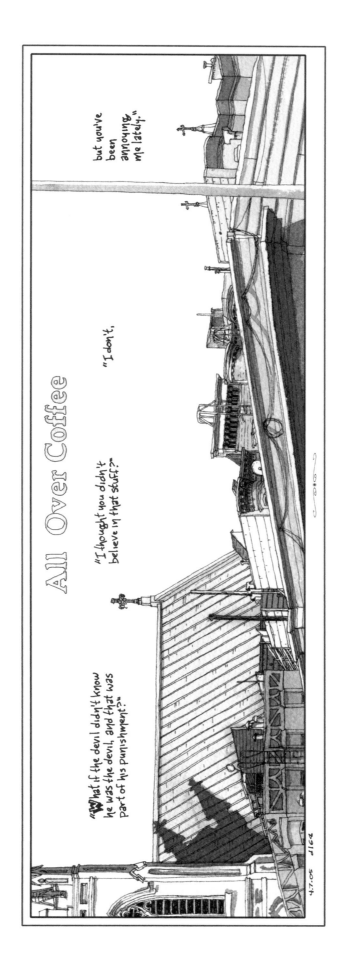

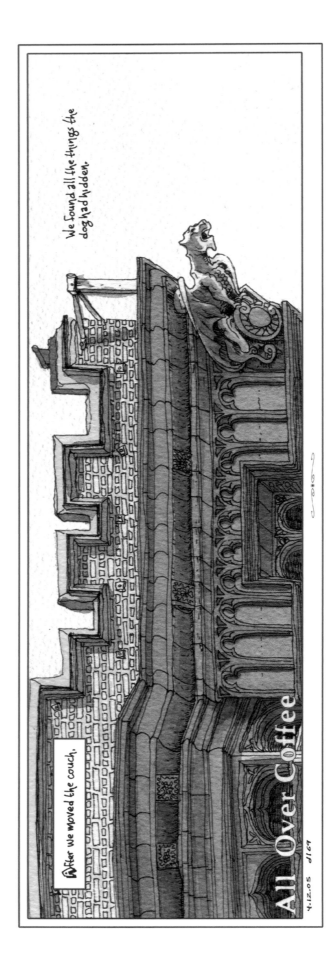

After we moved the couch,

We found all the things the dog had hidden.

All Over Coffee

4.12.05 d169

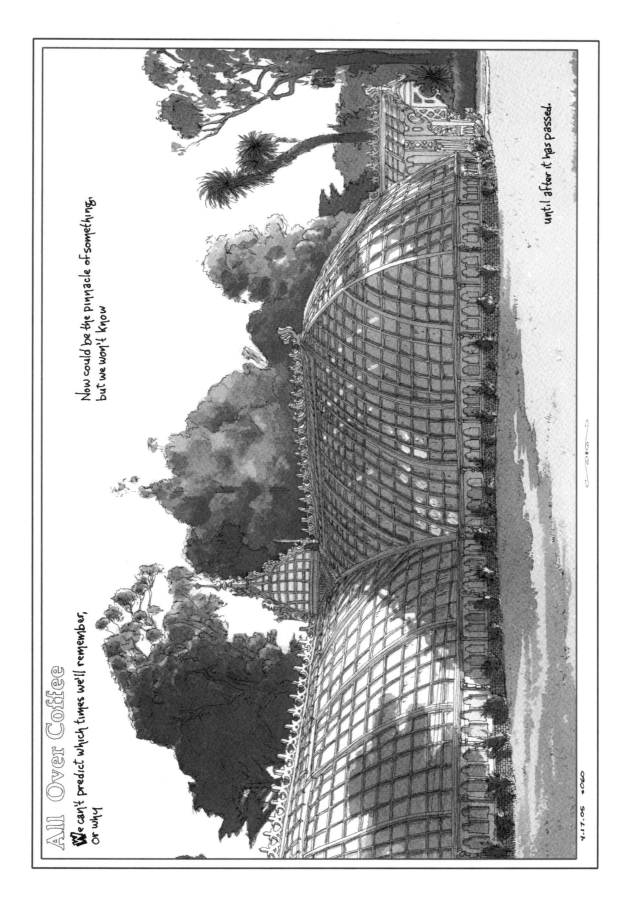

All Over Coffee

We can't predict which times we'll remember, or why

Now could be the pinnacle of something, but we won't know

until after it has passed.

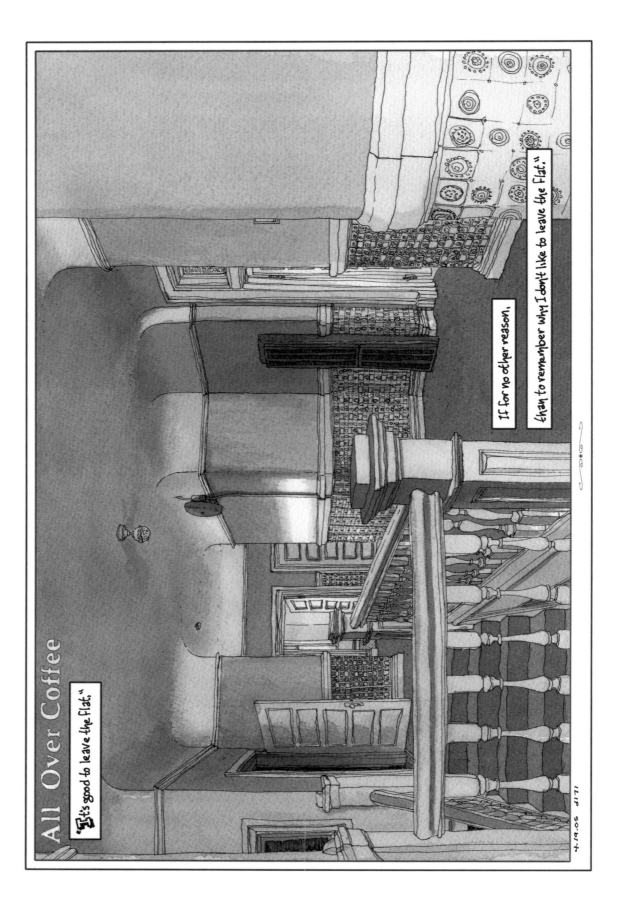

All Over Coffee

"It's good to leave the Flat,"

If for no other reason,

than to remember why I don't like to leave the Flat."

4-14-05

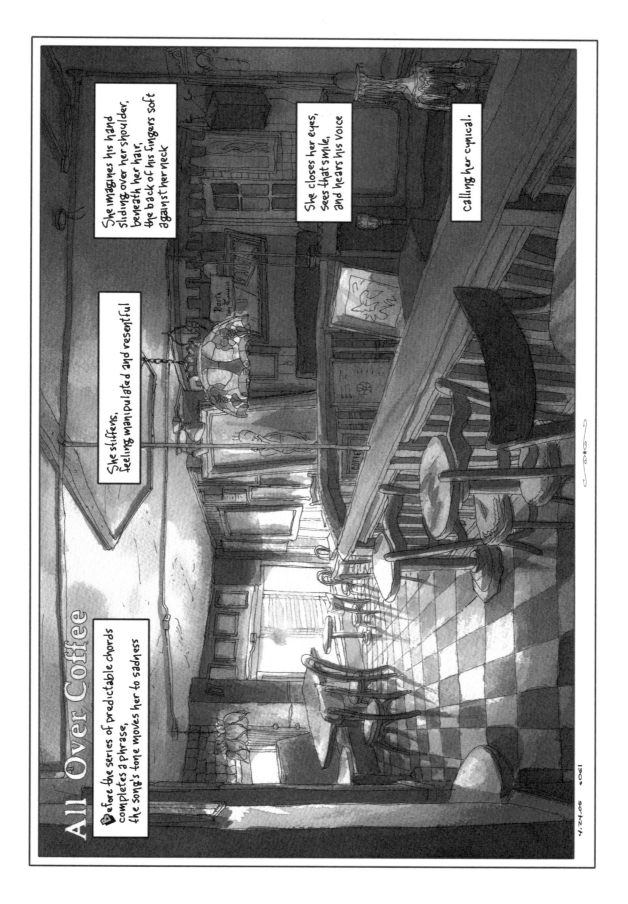

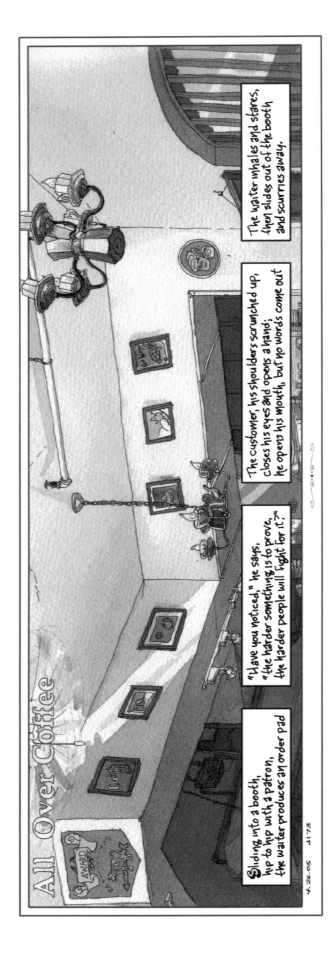

All Over Coffee

Sliding into a booth, hip to hip with a patron, the waiter produces an order pad

"Have you noticed," he says, "the harder something is to prove, the harder people will fight for it."

The customer, his shoulders scrunched up, closes his eyes and opens a hand; he opens his mouth, but no words come out

The waiter whales and stares, then slides out of the booth and scurries away.

4.26.05 d173

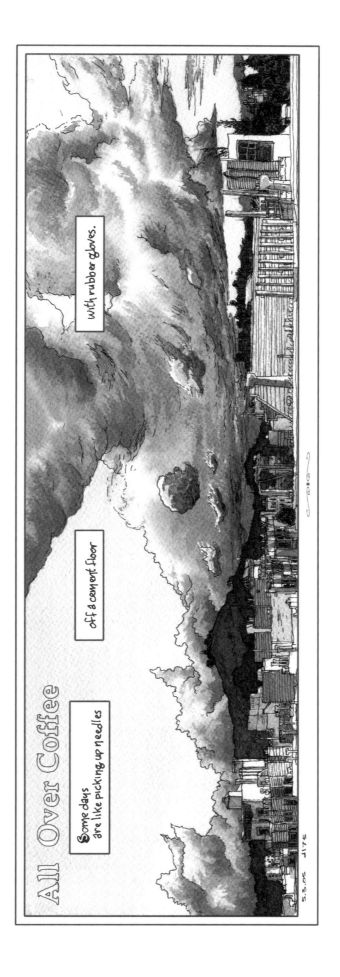

All Over Coffee

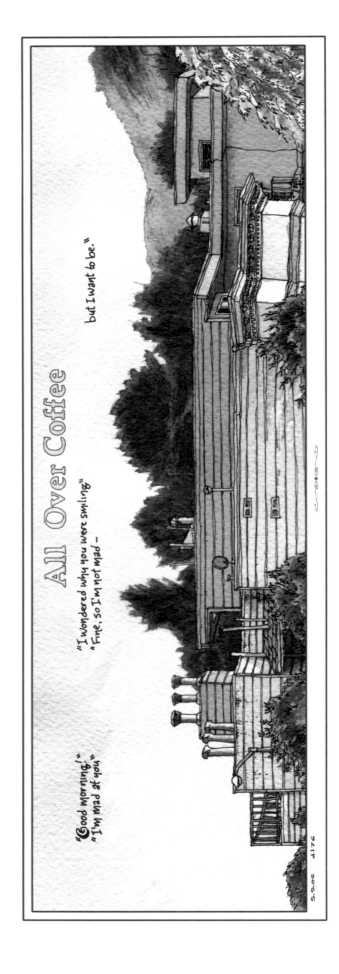

"Good morning!"
"I'm mad at you."

"I wondered why you were smiling."
"Fine, so I'm not mad —

but I want to be."

All Over Coffee

Their bed is in the bay window of their studio apartment; the heater is in the hall

Before going to sleep, he stands on the bed, takes off his pants and swings them around like a ceiling fan to circulate heat

From there he can see into several neighbors' windows, but they never do anything interesting.

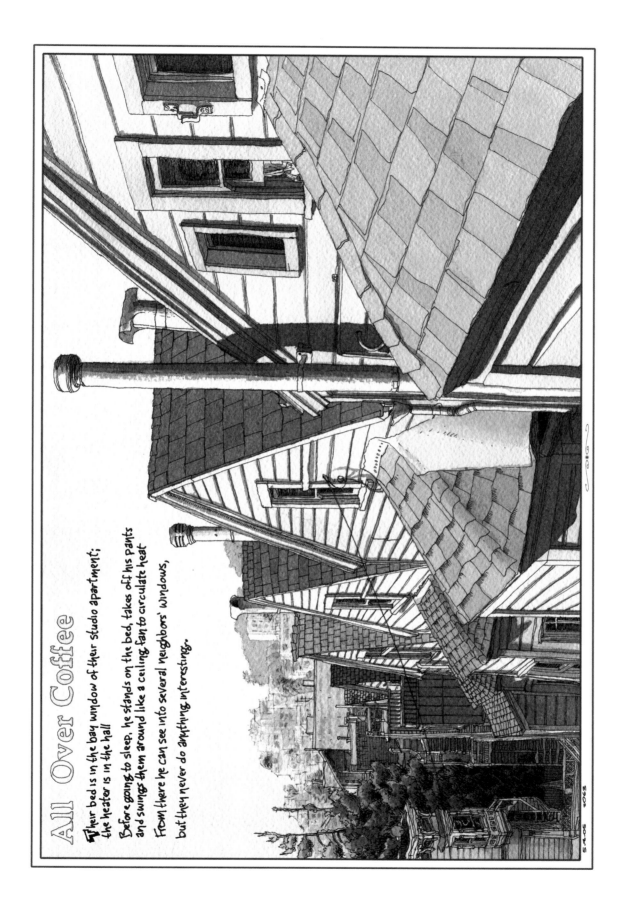

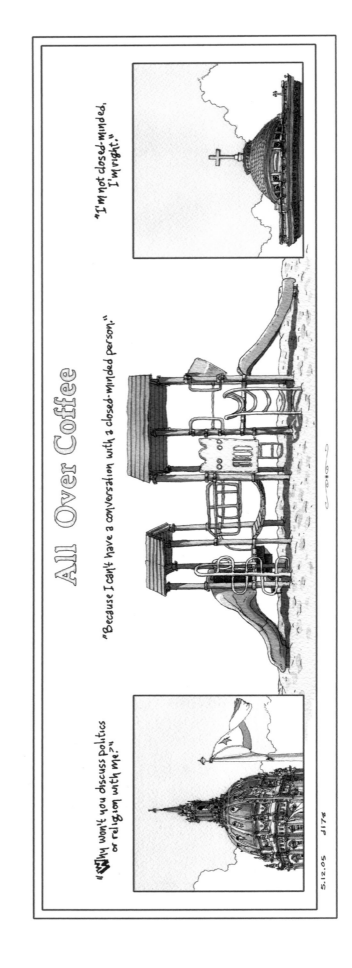

All Over Coffee

"Why won't you discuss politics or religion with me?"

"Because I can't have a conversation with a closed-minded person."

"I'm not closed-minded, I'm right."

5.12.05 J17≈

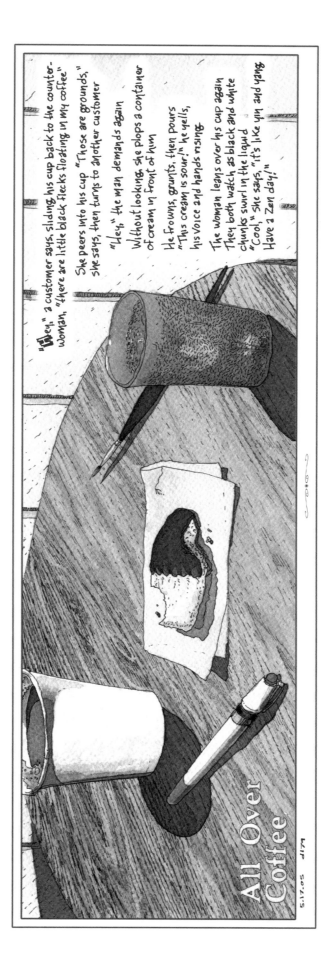

"Hey," a customer says, sliding his cup back to the counter - woman. "there are little black flecks floating in my coffee"

She peers into his cup "Those are grounds," she says, then turns to another customer

"Hey," the man demands again

Without looking, she plops a container of cream in front of him

He frowns, grunts, then pours "This cream is sour!" he yells, his voice and hands rising.

The woman leans over his cup again. They both watch as black and white chunks swirl in the liquid "Cool," she says, "it's like yin and yang. Have a Zen day!"

All Over Coffee

5.17.05 d174

All Over Coffee

5.26.05 d182

"You have to, otherwise you'd go crazy from all that thinking"
"Maybe it's because of all those thoughts that so much gets done"

"Maybe you're over-thinking"
"The thought has crossed my mind."

"You think too much"
"But I get a lot done"

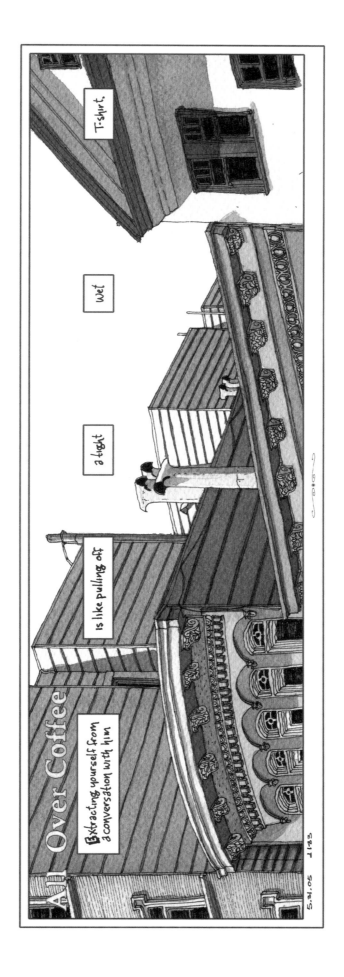

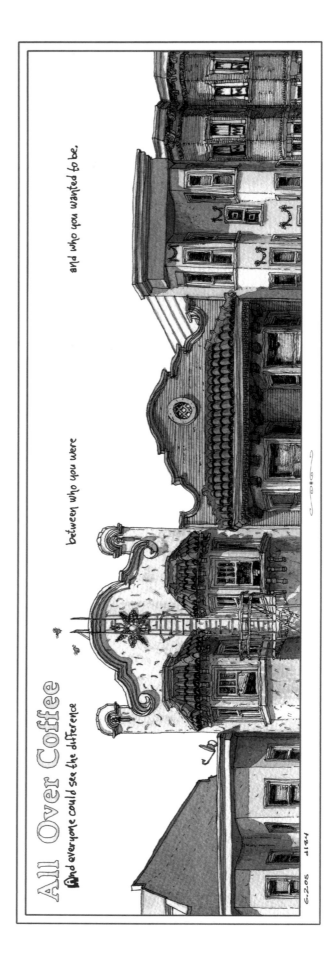

All Over Coffee

And everyone could see the difference

between who you were

and who you wanted to be.

6.2.05 P124

All Over Coffee

A drop of wetness hits her neck; it's beginning to rain.

The droplets are so small that rather than fall, they dance like dust after a sheet of plywood has fallen over.

Last night the air was humid and thick.

This morning she had bad dreams, then they argued over breakfast.

Now the air pressure was noticeably lifting, and without trying, she sighed and smiled.

What had they been so tense about anyway?

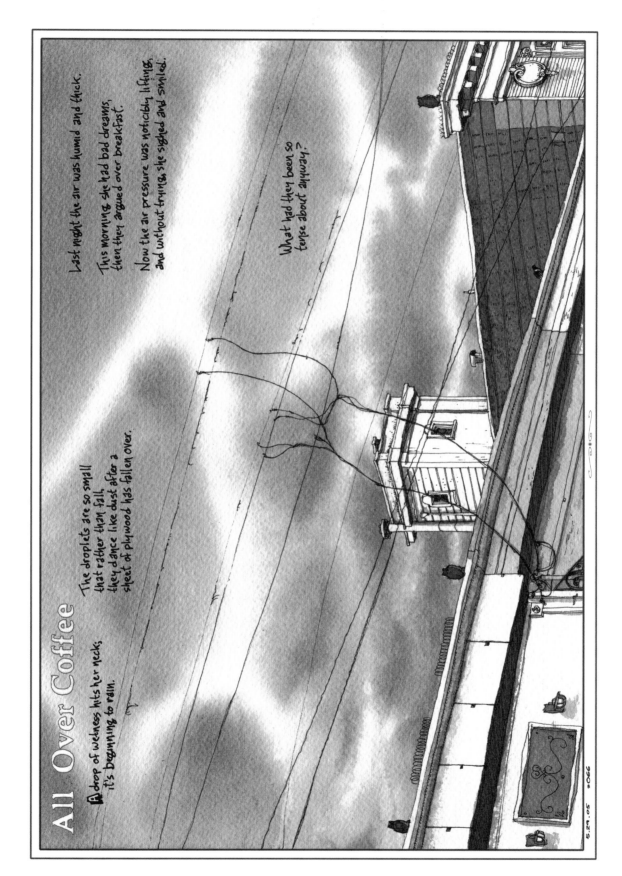

5.29.05 ⊃O64

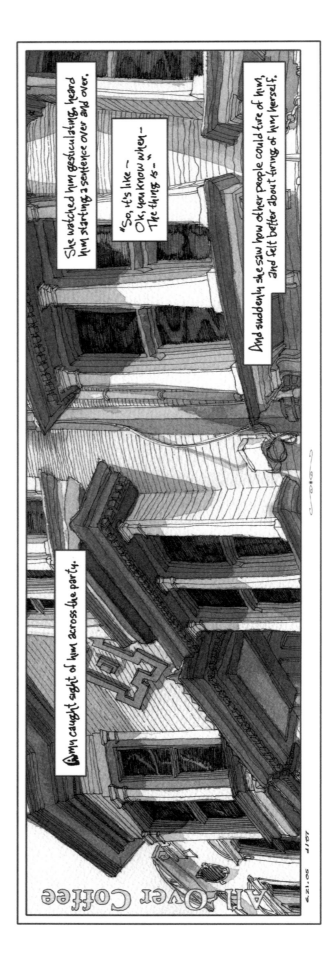

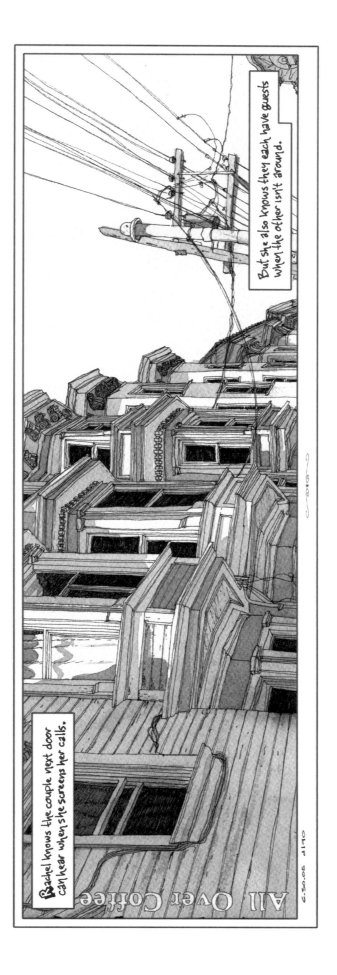

All Over Coffee

"I keep thinking I'm supposed to confess something," she says, standing in his attic, ducking to avoid the roofing nails protruding from the ceiling. "like I should open up."

The pitched roof was steep, the air was thick and humid, and it seemed to her that he wasn't paying attention.

She peeled the sweat-soaked shirt away from her chest, flapped it a few times to move some air, then continued, "Thing is, I don't feel closed, and to search for something deep or personal just to share would be phony."

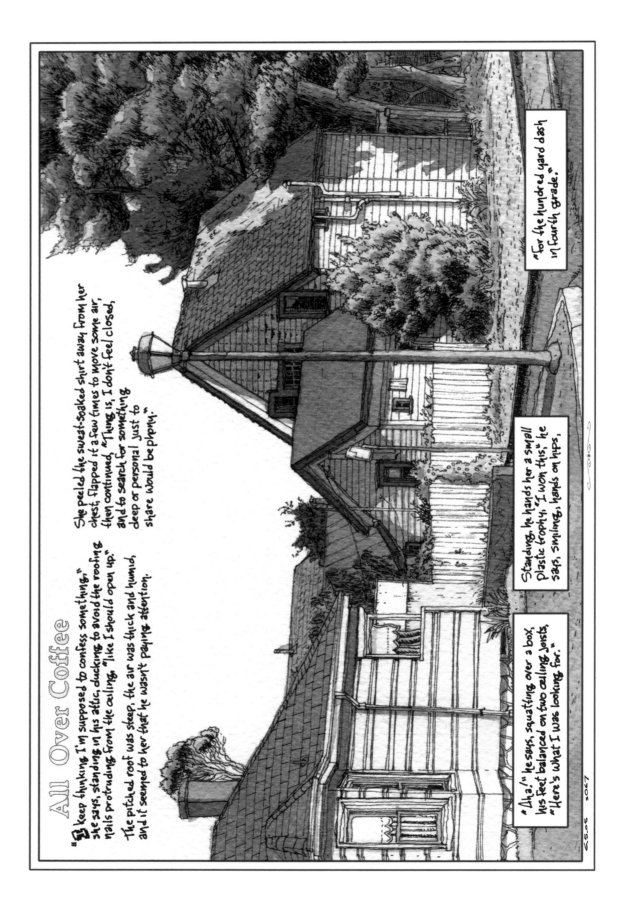

"Aha!" he says, squatting over a box, his feet balanced on two ceiling joists, "Here's what I was looking for."

"Standing, he hands her a small plastic trophy. "I won this," he says, smiling, hands on hips,

"For the hundred yard dash in fourth grade."

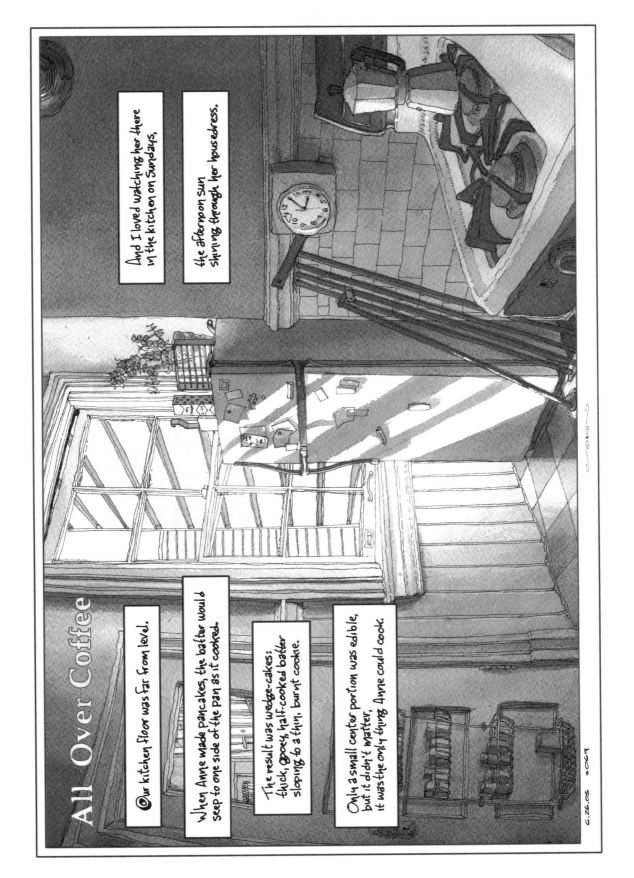

All Over Coffee

ⓒur kitchen floor was far from level.

When Anne made pancakes, the batter would seep to one side of the pan as it cooked.

The result was wedge-cakes: thick, gooey, half-cooked batter sloping to a thin, burnt cookie.

Only a small center portion was edible, but it didn't matter, it was the only thing Anne could cook.

And I loved watching her there in the kitchen on Sundays,

the afternoon sun shining through her housedress.

6.26.05 #069

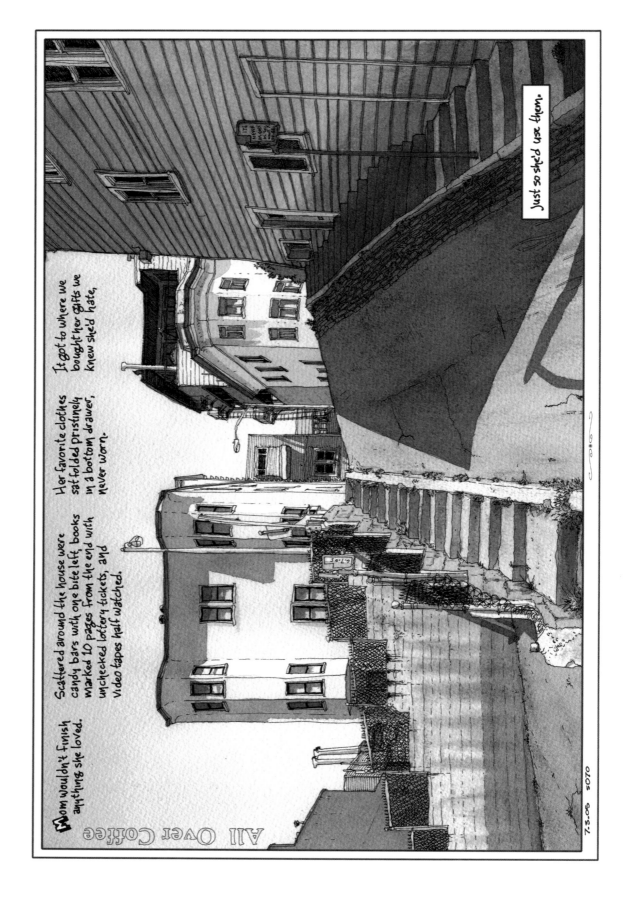

All Over Coffee

Mom wouldn't finish anything she loved.

Scattered around the house were candy bars with one bite left, books marked 10 pages from the end with unchecked lottery tickets, and video tapes half watched.

Her favorite clothes sat folded pristinely in a bottom drawer, never worn.

It got to where we bought her gifts we knew she'd hate,

Just so she'd use them.

7.5.05 s070

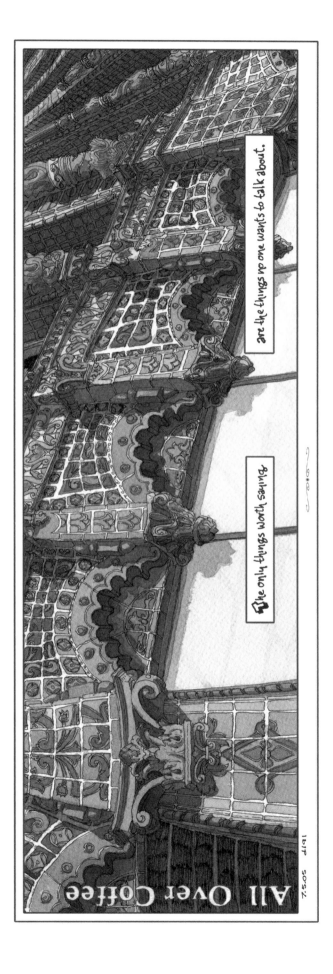

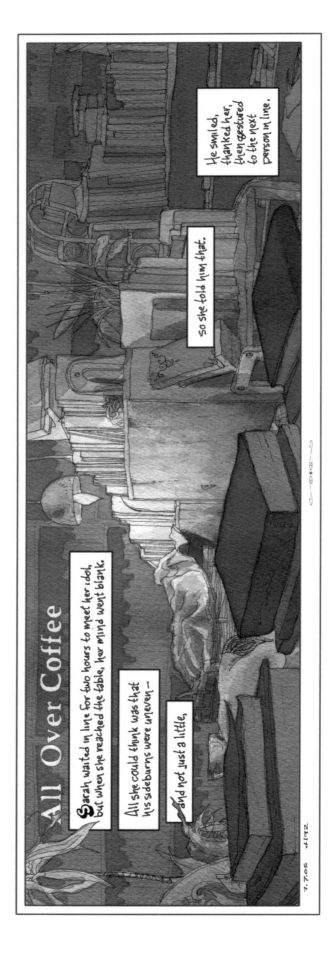

All Over Coffee

Sarah waited in line for two hours to meet her idol, but when she reached the table, her mind went blank.

All she could think was that his sideburns were uneven—

and not just a little,

so she told him that.

He smiled, thanked her, then gestured to the next person in line.

7.7.05

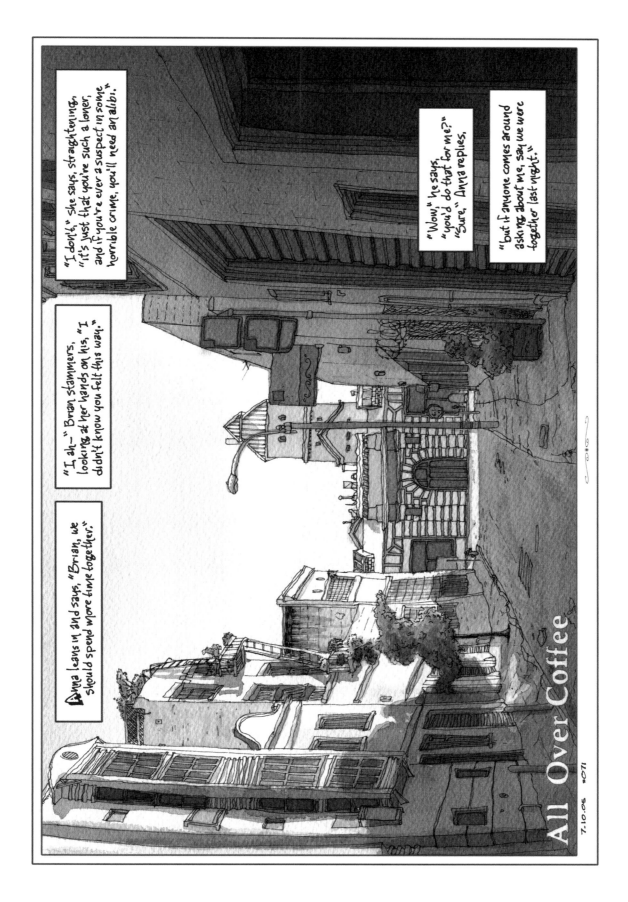

All Over Coffee

7.10.05 #071

129

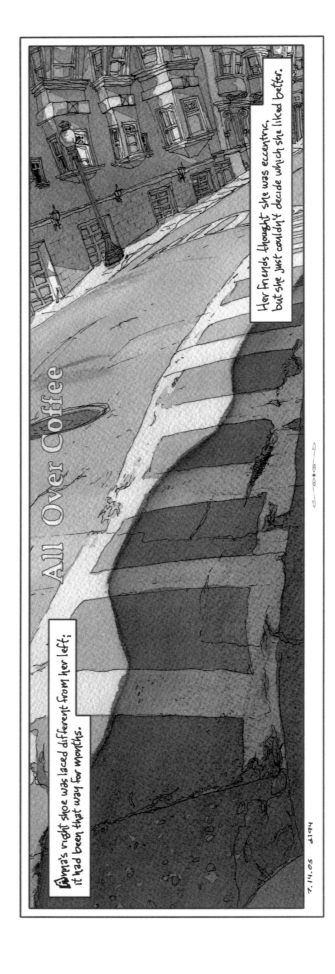

All Over Coffee

Anna's right shoe was laced different from her left; it had been that way for months.

Her friends thought she was eccentric, but she just couldn't decide which she liked better.

7.14.05

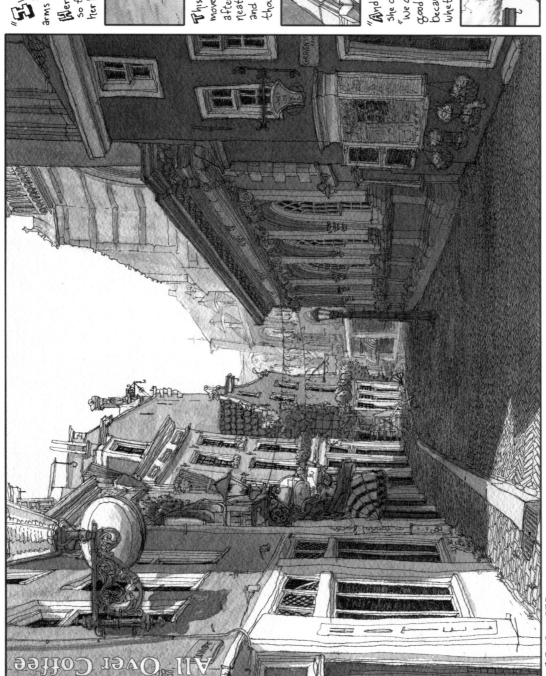

"I've been rethinking," she said, sitting up in bed, arms wrapped around her legs.

Her chin rested on her knees so that when she spoke, her head bobbed up and down.

This was after they had moved in together, after their routines were neatly aligned, and after they no longer thought about it.

"And I've changed my mind," she continued, "we do deserve everything good that comes our way, because the bad comes whether we deserve it or not."

All Over Coffee

4.7.05 2075

135

All Over Coffee

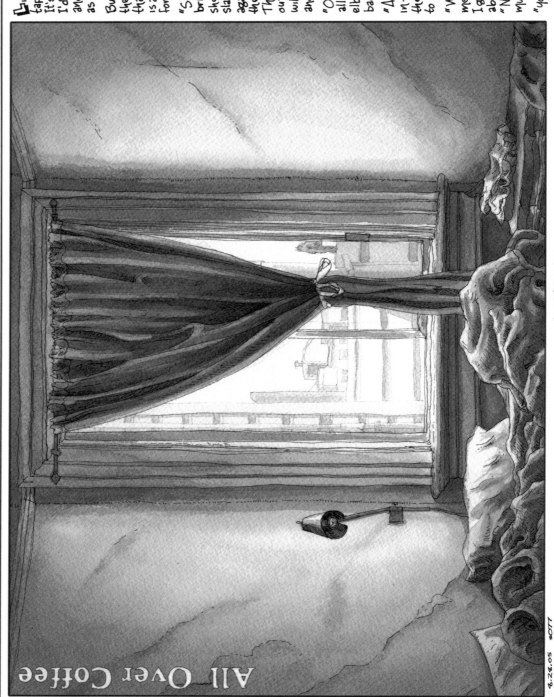

Lia leans over and taps my forehead.
It's 6 a.m.
I'd rather be sleeping, and tell her this as curtly as possible.

But she has this theory, she says, that a single day is a metaphor for an entire life.

"Some people are bright in the morning," she says, sitting up, slapping a finger against her palm, "yet they tire out by evening. That means they start out strong in life, but will give in to old age and death easily."

"Others are bright all day," she adds, elbowing me in the back. "That's me."

"And some are grouchy in the morning, lost in the afternoon, and come to life at night."

"We're talking about me now, aren't we?"
I grumble, no longer able to avoid waking up.
"No, silly," she says, mussing up my hair,

"you're grumpy all the time."

6.28.05 2011

All Over Coffee

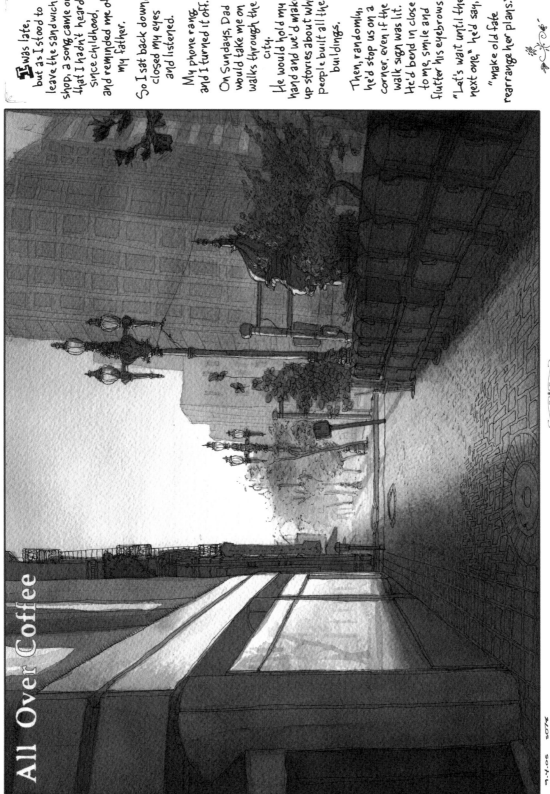

I was late, but as I stood to leave the sandwich shop, a song came on that I hadn't heard since childhood, and reminded me of my father.

So I sat back down, closed my eyes and listened.

My phone rang and I turned it off.

On Sundays, Dad would take me on walks through the city.

He would hold my hand and we'd make up stories about why people built all the buildings.

Then, randomly, he'd stop us on a corner, even if the walk sign was lit. He'd bend in close to me, smile and flutter his eyebrows.

"Let's wait until the next one," he'd say, "make old fate rearrange her plans."

All Over Coffee

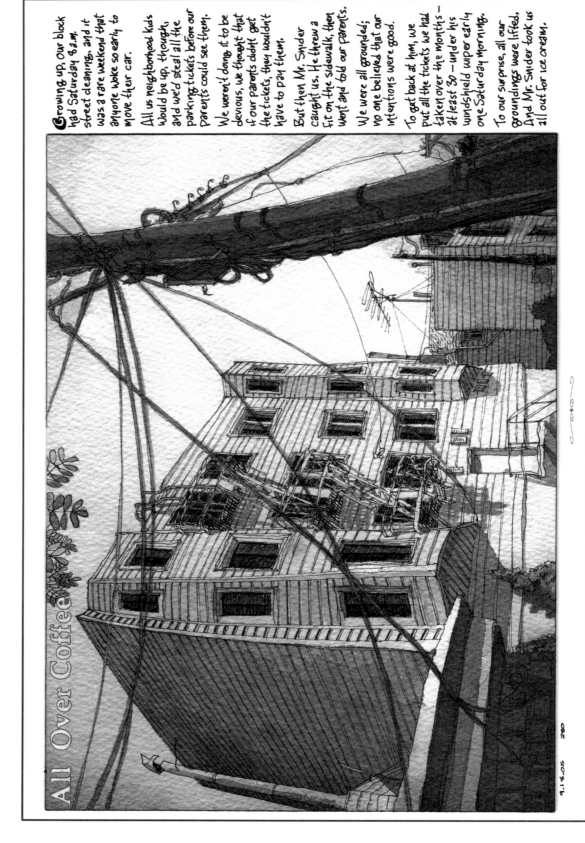

Growing up, our block had Saturday 8 a.m. street cleaning, and it was a rare weekend that anyone woke so early to move their car.

All us neighborhood kids would be up, though, and we'd steal all the parking tickets before our parents could see them.

We weren't doing it to be devious, we thought that if our parents didn't get the tickets, then they wouldn't have to pay them.

But then Mr. Snider caught us. He threw a fit on the sidewalk, then went and told our parents.

We were all grounded; no one believed that our intentions were good.

To get back at him, we put all the tickets we had taken over the months — at least 30 — under his windshield wiper early one Saturday morning.

To our surprise, all our groundings were lifted. And Mr. Snider took us all out for ice cream.

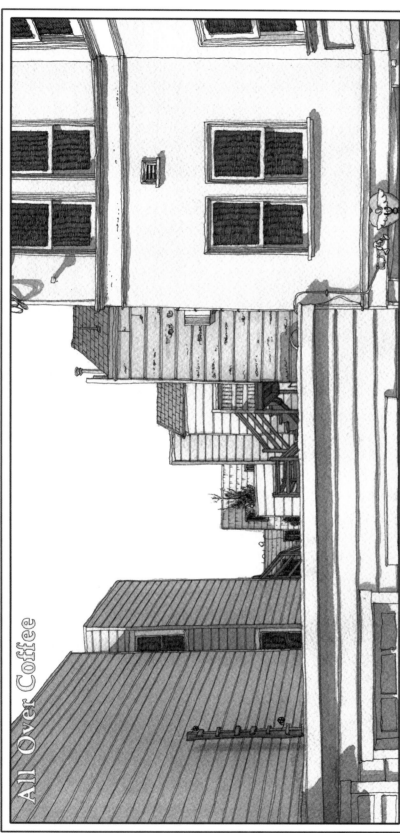

All Over Coffee

9.25.05 281

Emily told me I owed him a second chance, so I agreed to meet Gary for dinner.

He was already there when I arrived. Seated with him were his parents who were visiting from out of state. They were dressed entirely in denim and barely acknowledged me when I sat down.

Gary didn't eat. Instead, he spent the meal explaining that the problem with baring your soul to someone is that by releasing cherished feelings, you invite contrary emotions in.

"You'll find yourself," he urged, "embodying thoughts and feelings in direct opposition to those you just confessed. Such a state is irreconcilable."

He threw up his hands. I looked over to his parents. They sat glassy eyed, having tuned out long ago. I wanted to excuse myself, pretend I was going to the restroom, and leave the restaurant.

Gary leaned in and put his hand on my shoulder. "Therefore," he said, "it is best to always speak the opposite of your beliefs.

Only then can you hold your true self intact."

And with that he left the table. As soon as he was out of sight I stood and left without a word.

Outside, I expected to find Gary either waiting for me or jumping into a cab. In my peripheral I caught someone getting on a bus, but can't say for sure if it was him.

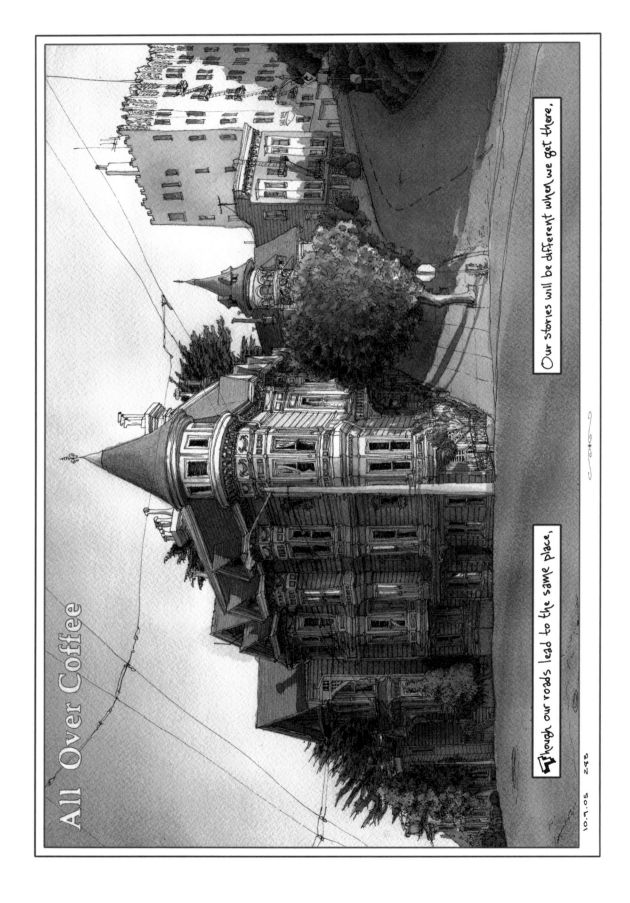

All Over Coffee

Though our roads lead to the same place,

Our stories will be different when we get there.

10.7.05 245

140

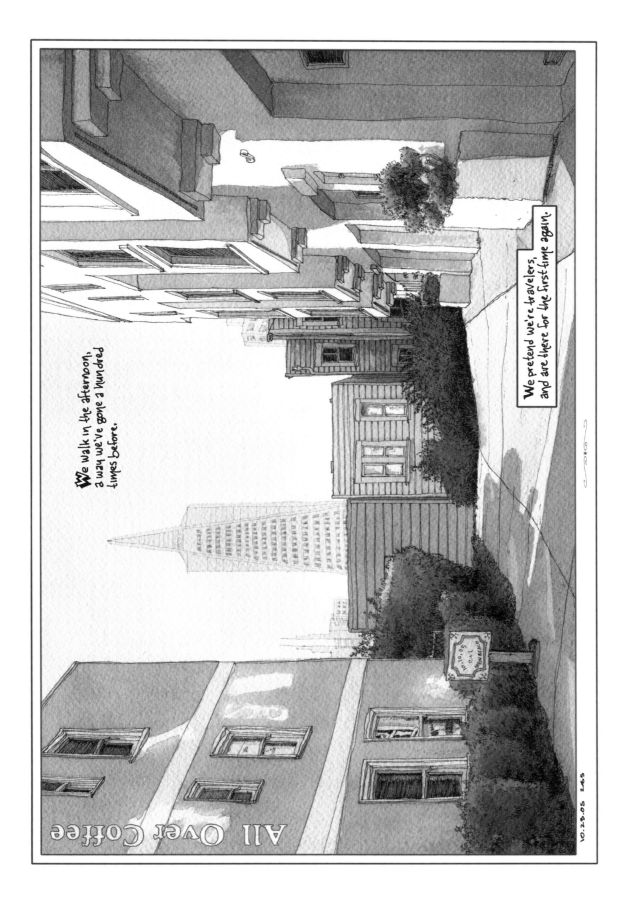

All Over Coffee

We walk in the afternoon, a way we've gone a hundred times before.

We pretend we're travelers, and are there for the first time again.

10.28.05 265

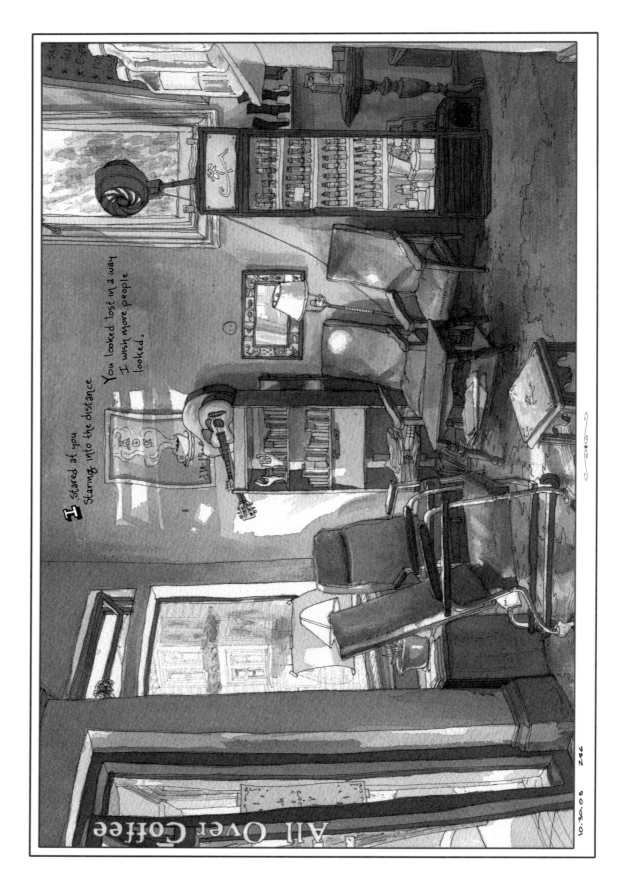

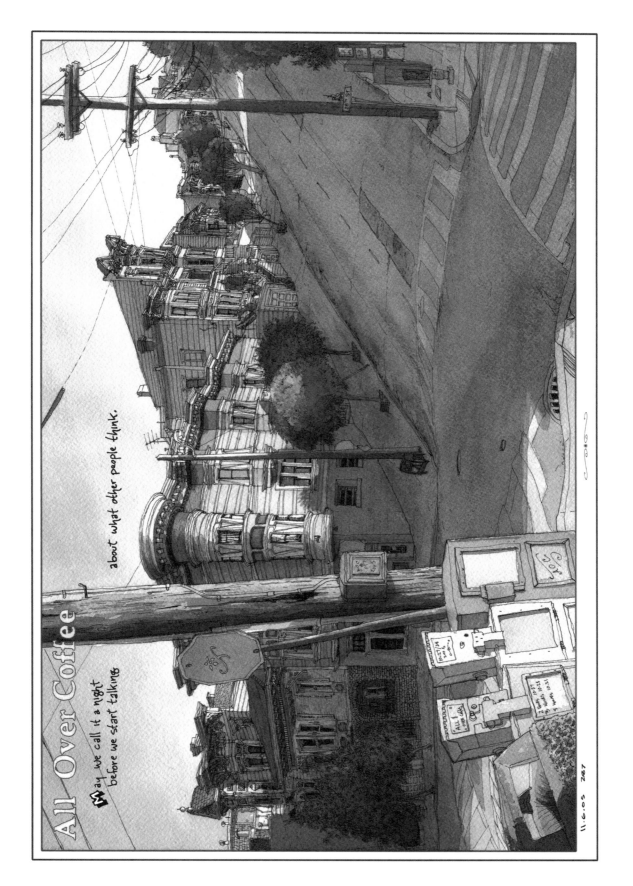

All Over Coffee

May we call it a night before we start talking about what other people think.

11.6.05 287

143

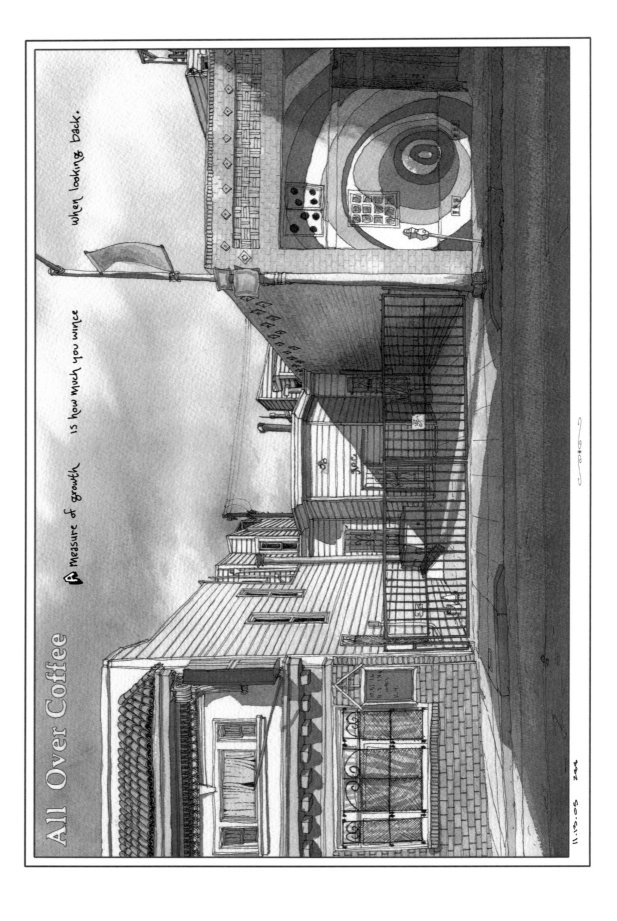

All Over Coffee

A measure of growth is how much you wince when looking back.

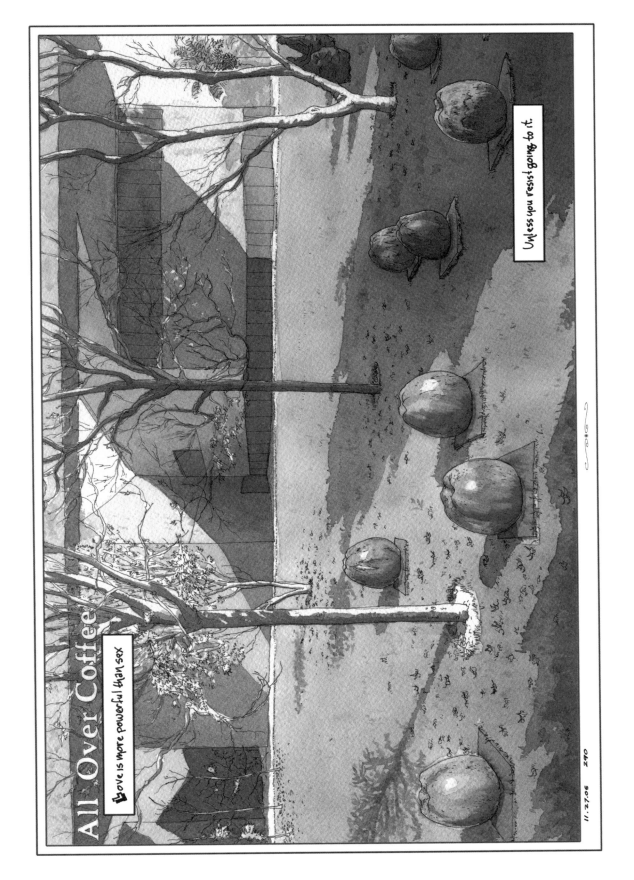

All Over Coffee

Love is more powerful than sex

Unless you resist going to it.

11.27.05 290

All Over Coffee

We longed for a freedom

of simply knowing less.

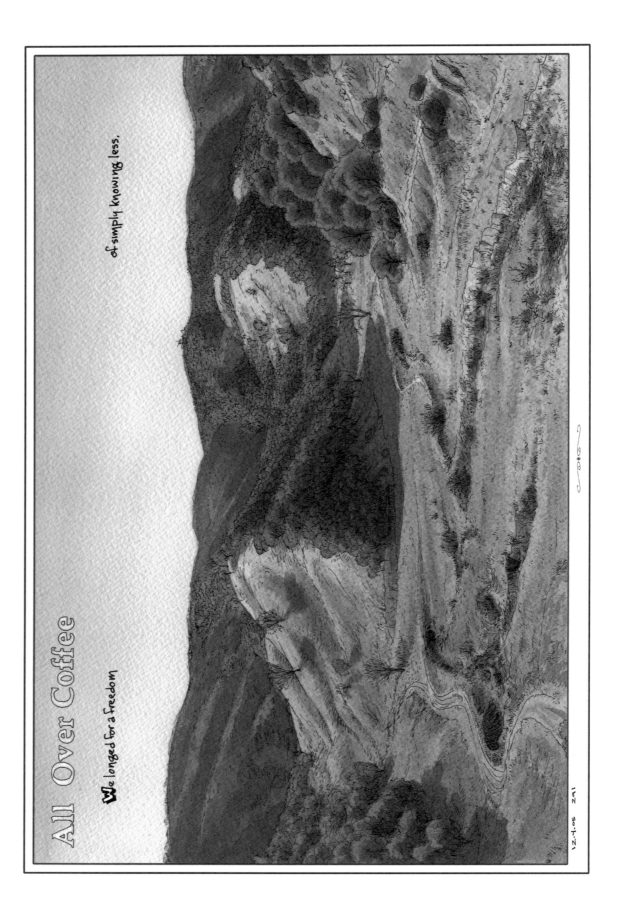

12.4.05 291

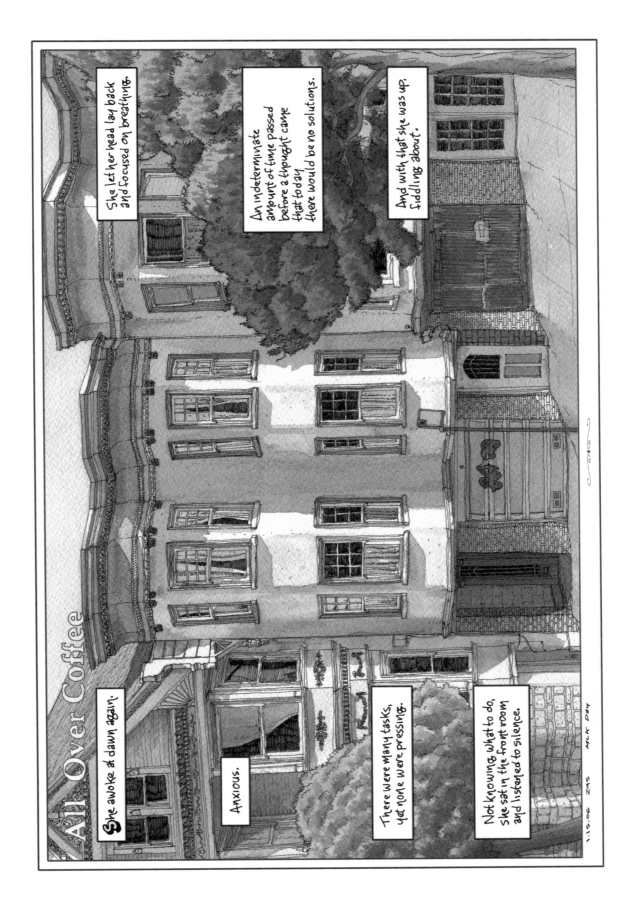

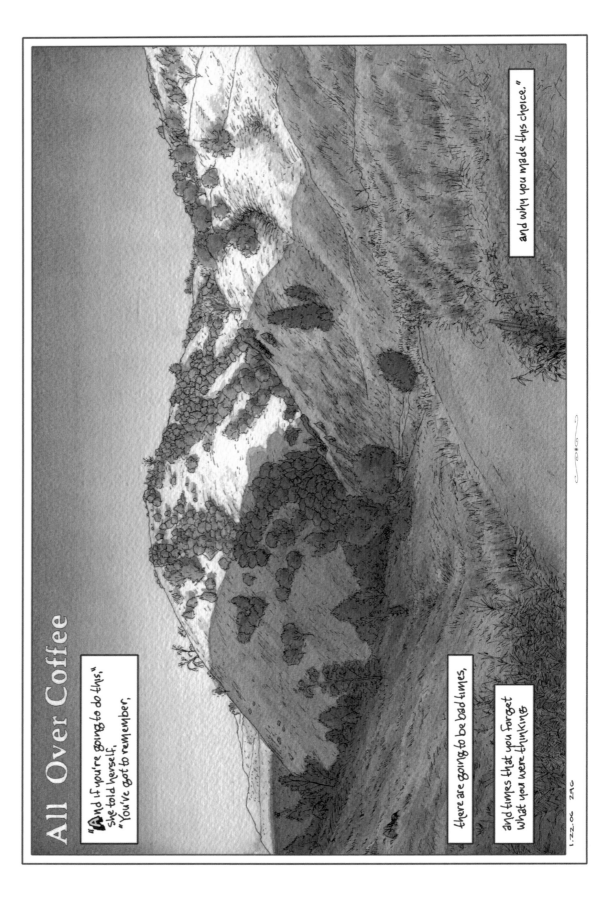

All Over Coffee

"And if you're going to do this," she told herself, "you've got to remember,

there are going to be bad times,

and times that you forget what you were thinking

and why you made this choice."

1.22.06 ZAG

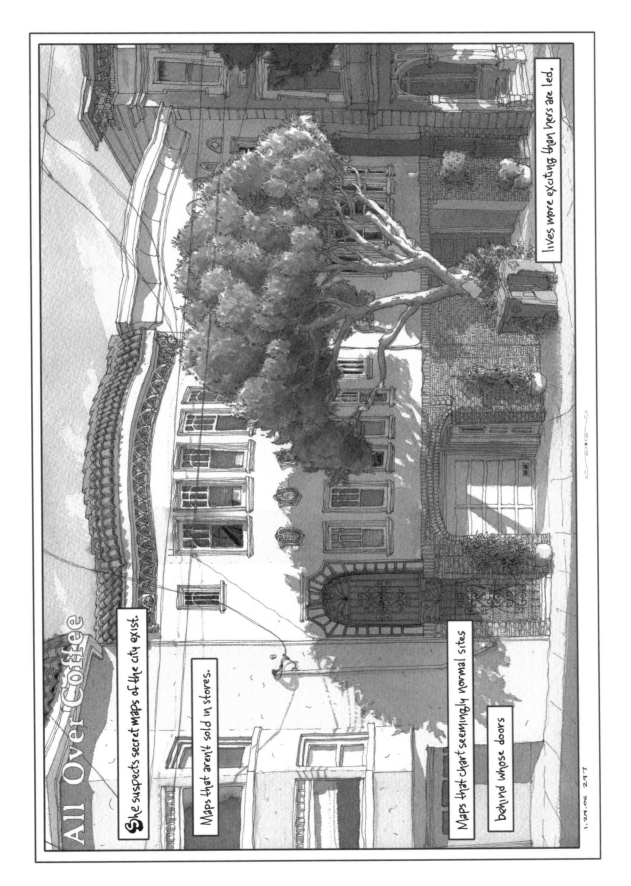

All OverCoffee

She suspects secret maps of the city exist.

Maps that aren't sold in stores.

Maps that chart seemingly normal sites

behind whose doors

lives more exciting than hers are led.

1.24.06 247

149

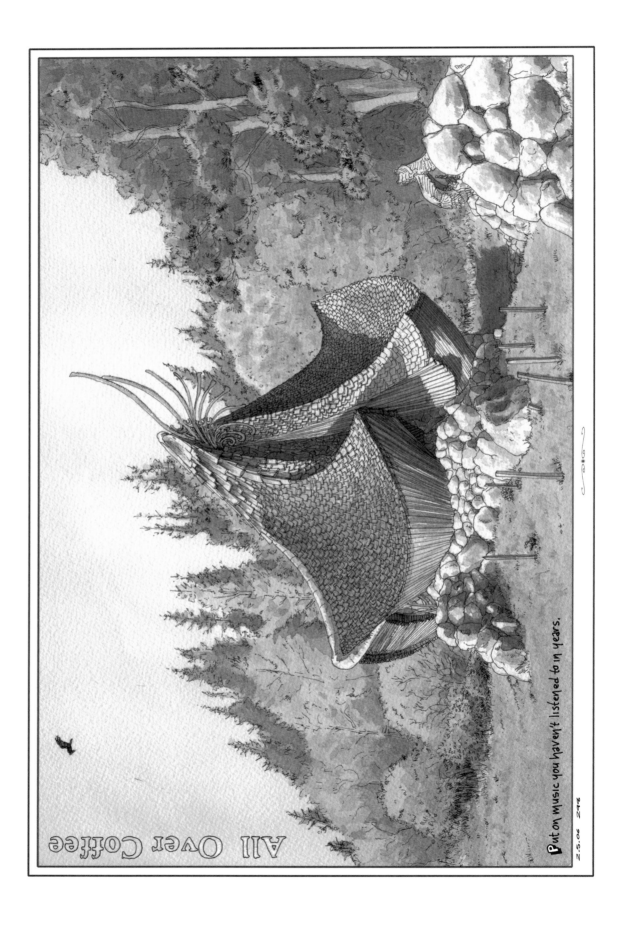

All Over Coffee

Put on music you haven't listened to in years.

2.5.06 248

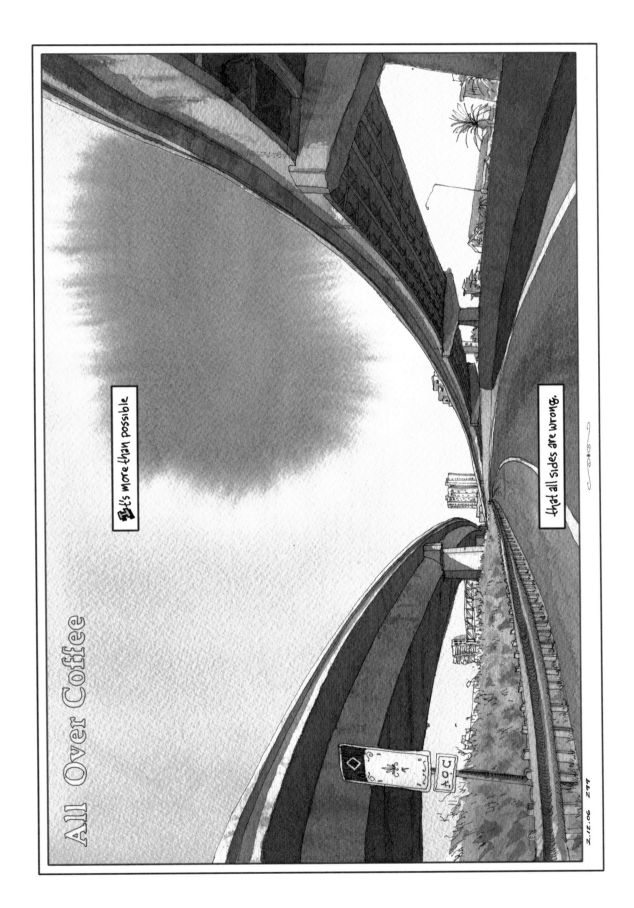

All Over Coffee

It's more than possible

that all sides are wrong.

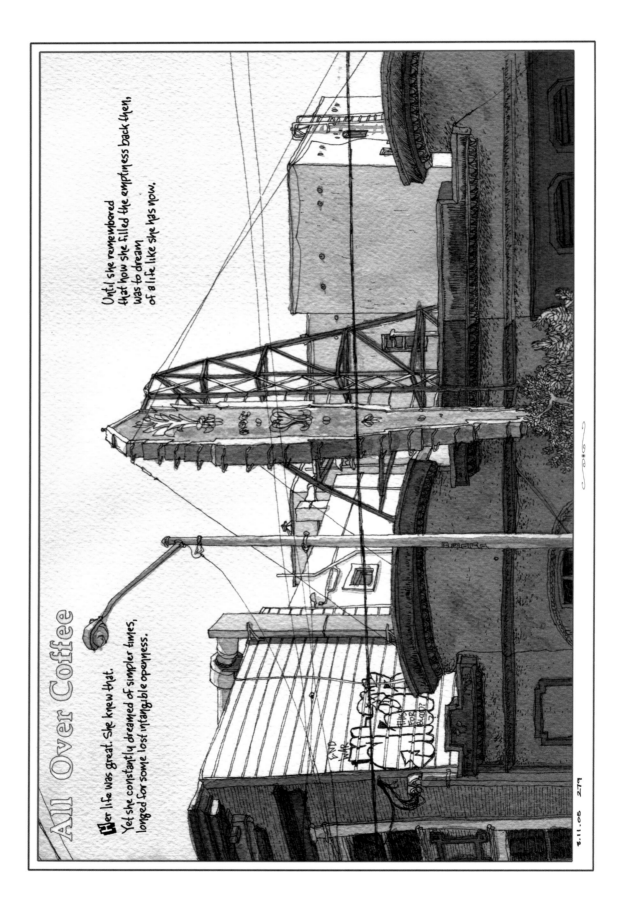

All Over Coffee

Her life was great. She knew that.
Yet she constantly dreamed of simpler times,
longed for some lost intangible openness.

Until she remembered
that how she filled the emptiness back then,
was to dream
of a life like she has now.

8.11.05 279

816

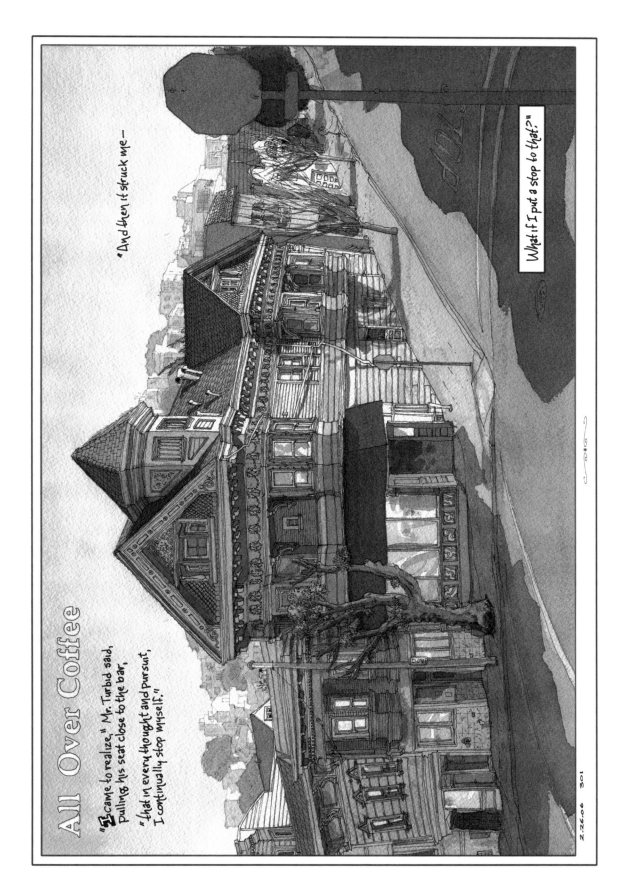

All Over Coffee

"**I** came to realize," Mr. Turbid said, pulling his seat close to the bar,

"that in every thought and pursuit, I continually stop myself."

"And then it struck me —

"What if I just stop to think?"

153

All Over Coffee

Months later,
he emerged from his room,
leaned over the railing
and breathed fresh morning air.

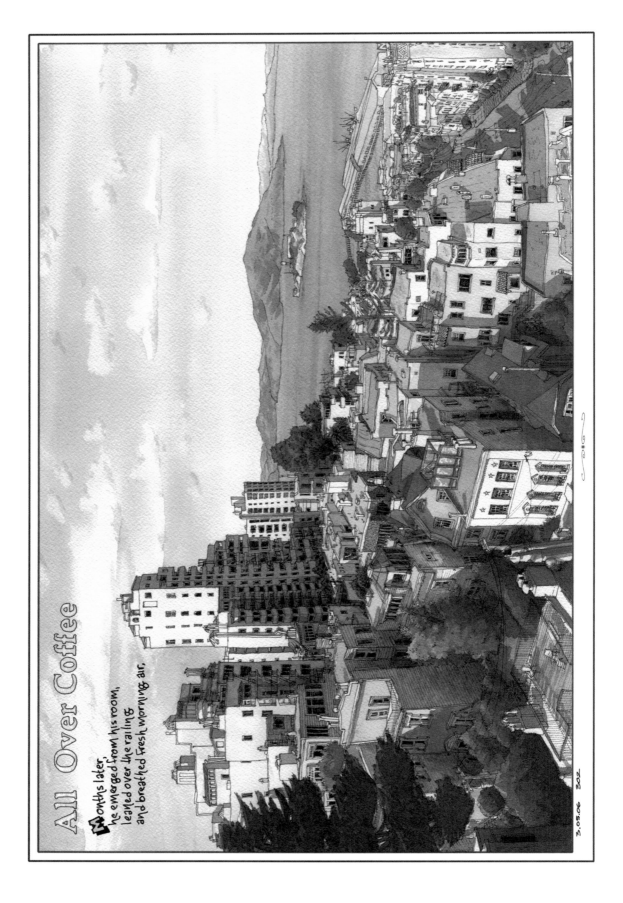

3.05.06 302

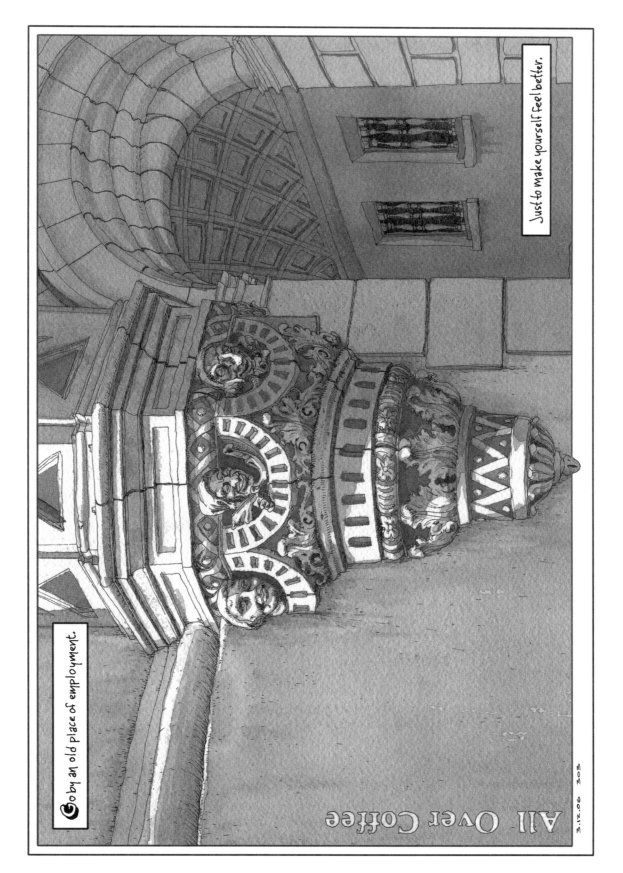

Go by an old place of employment.

Just to make yourself feel better.

All Over Coffee

3.12.06 305

155

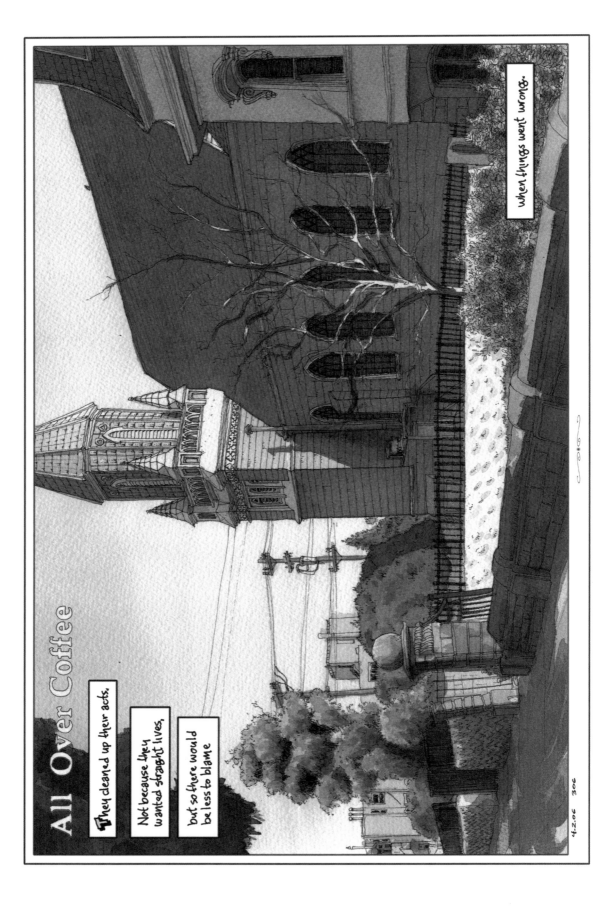

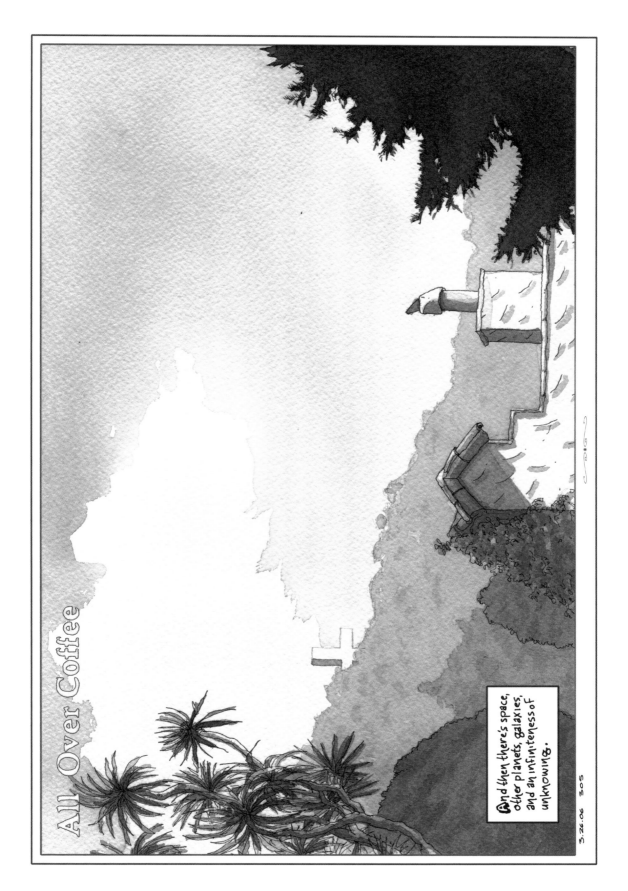

All Over Coffee

And then there's space, other planets, galaxies, and an infiniteness of unknowing.

3.26.06 305

157

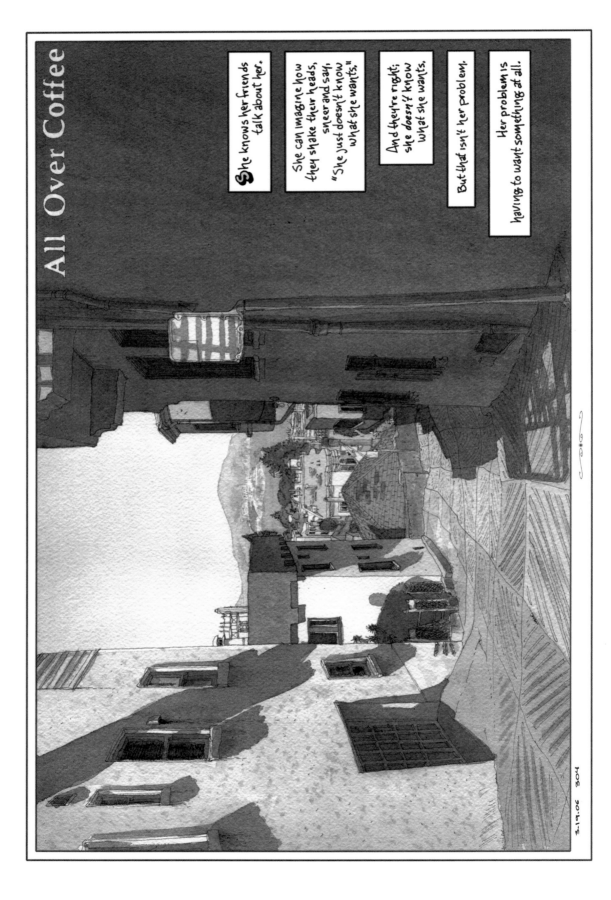

She knows her friends talk about her.

She can imagine how they shake their heads, sneer and say, "She just doesn't know what she wants."

And they're right; she doesn't know what she wants,

But that isn't her problem.

Her problem is having to want something at all.

3.19.06 304

All Over Coffee

While talking, she wiped crumbs to the edge of the table with a napkin. It was an old habit; she didn't see herself doing it.

I wondered what would happen if I grabbed hold of her arm and held it still—

Would her body start to shake? Would she convulse like a jammed machine?

She dragged the napkin again and something smeared, leaving an oily trail across the table.

She wiped quickly, over and over until the substance vanished. Then she folded the napkin and tucked it under a plate.

I looked from the table to her face. Her eyes were wanton and desperate.

She had been talking all the while, and I hadn't heard a word.

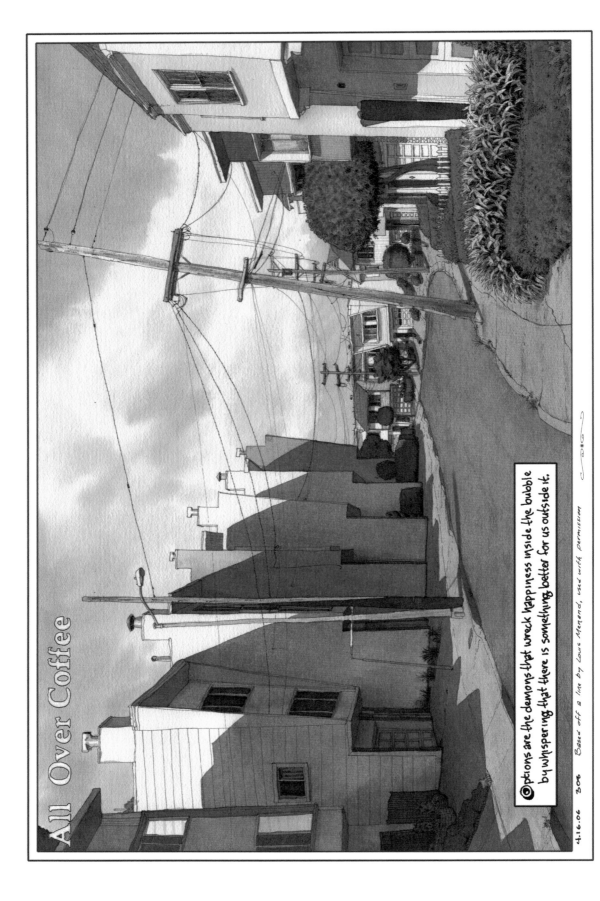

All Over Coffee

©ptions are the demons that wreck happiness inside the bubble by whispering that there is something better for us outside it.

4.16.06 306 Based off a line by Louis Menand, used with permission

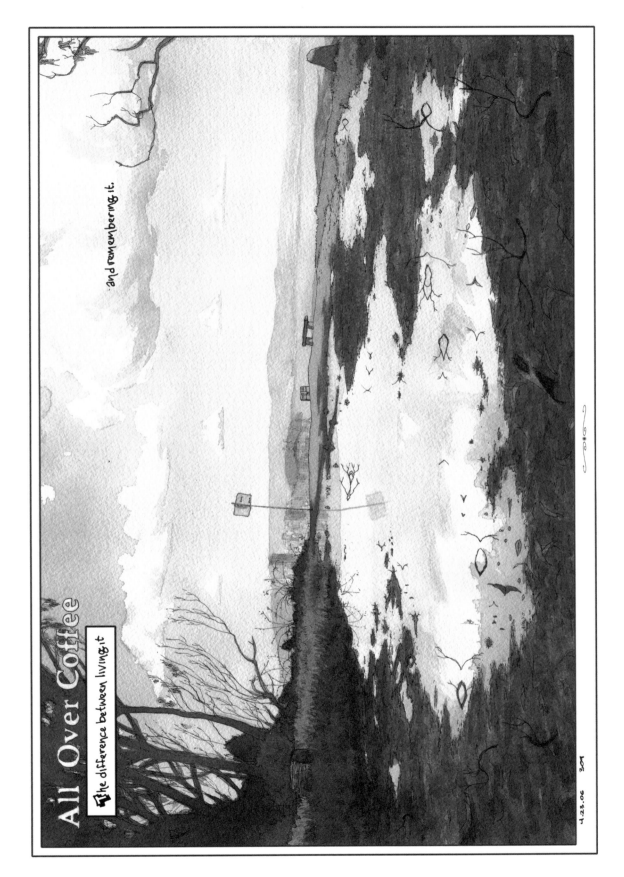

All Over Coffee

The difference between living it

...and remembering it.

4.23.06 309

I chose to write an afterword because I wanted to offer my story and not have it color your experience with the strips before engaging with them. I believe my intentions may add insight to how you see the work, but ultimately, each piece must first stand on its own.

Drawing and Writing

Drawings for ALL OVER COFFEE are done with ink and inkwash (india ink mixed with water) on watercolor paper. The writing is my own, and fictional, contrary to the common assumption that the bits of conversation in the strip come from things I've overheard.

There are exceptions, but the text generally comes first for a strip. Each piece of writing starts as a thought or observation jotted in a notebook that I carry with me at all times. Every week I go through my notebooks to find a thought that jumps out, then I have to read, edit, put it away, and repeat the process before deciding to draw. The drawing process is more linear. Once I choose a site and time of day to capture, I just sit down and put pen to page. I don't use pencils, it's straight to ink.

Drawings are begun on site. I have a lightweight collapsible stool and portable drawing kit that fits easily into a backpack. Early on, drawings were made start to finish on site, including the ink washes. But as the drawings became more complex and my desire for light and shadow more specific, I began doing only the line work on site, and completing ink washes in the studio from reference photos.

I find sites by scouting the city, taking walks and looking. Often, after finding a site to draw for a piece of writing, I'll revisit it several times to document the light at different hours. Sometimes I'll draw a site without having written for it because the light is striking or some quality of the scene calls to me, then write to that. Those strips always take longer because the writing process comes second, often requiring multiple stories until one resonates with the drawing. I think of this as going into a piece backwards, which can be liberating and refreshing, forcing me to stay conscious with the process.

My drawing skills have matured considerably over the course of 300 strips. The first drawings for ALL OVER COFFEE were 5 x 7 inches for the dailies, and 9 x 12 for Sunday strips, and took between one and six hours to produce. This is only drawing time and doesn't include scouting, writing or assembling the components into a finished strip. As my skills grew and focus shifted from rooftops and details to fuller scenes, paper size increased. The largest drawings to date are now 18 x 24 inches and take around eight hours on site and anywhere from ten to twenty in the studio. These numbers are hard to calculate, though, since I generally work on two to five drawings at once and often let larger drawings sit on my table for weeks between sessions, taking months to complete.

Pole & Tree, Golden Gate @ Central, 1.4.04

How All Over Coffee Came To Be, and How I Got Here

In 1994 I graduated with a Fine Art degree from Carnegie Mellon University and moved from Pittsburgh, Pennsylvania to San Francisco. I worked part time jobs so I could have just enough money to live and as much time to write and draw as possible. I showed my work at cafes and small galleries and for years made mini-comics, spending hours at Kinko's copying, folding and stapling. I left stacks of my books for free in cafes and slid them between books and newspapers in stores so people would stumble across them. Response from friends was good, and occasionally strangers wrote to tell me their thoughts. I met my wife, Joen, through one of my books left in a café. She found it and wrote to me as a fan. We began corresponding about art and life, and after a month of intriguing conversation we met and were instantly inseparable. A few months later we traveled across the country together in her Mazda Miata, leaving stacks of my newest book, ,Henry (spelled with a comma, confusing everybody forever), in bookstores and libraries as we went. A year after that we were married.

Slowly, my work gained notice. In 2002 I launched my first website, paulmadonna.com, where I posted a weekly cartoon, and by spring 2003 I had two pieces published in comic book collections and one in a local publication, the *San Francisco Reader*. By that summer I had been working full-time on a graphic novel for several months, but had gotten bogged down. The plot and outline were all down on paper, but when I began scripting it turned into a monster. With every scene two more were added. And each decision caused the last three to fall apart. I began distracting myself while in the studio, which drove me crazy. I feared I was becoming one of those artists who only wanted to make art, not one who actually made any.

Ladies Bartholomew, unfinished graphic novel, Summer 2003

Joen went to Mexico for a month and I stayed behind. It was a tough decision. I wanted to go, but money was getting tight, and I was determined to make the transition into supporting myself through my work. I didn't want to have a meaningless job ever again. A month away would have cost the same as two months at home, and a month felt like it could mean life or death in terms of a breakthrough. On my own for that time, I wrote and rewrote countless scenes and drew stacks of rough panels for the graphic novel, but enthusiasm in the studio was hard earned. Not only was the story doubling every day but I found that I didn't want to make anything up when drawing. With every scene I wanted to find the right furniture, objects and buildings. I justified getting away from the studio to scout locations, all of which resulted in little progress on the book.

In that month of endless walking, biking, and musing, I began to question myself about why I wasn't enjoying what I was doing. I had long ago gotten over the idea that an artist must suffer, and believed that if a person is to engage in art, to spend his time and not get recognition or money, then at the very least he should love doing it, not just love wanting to do it. It wasn't a question of whether I should be spending my time pursuing art, but how to do it with less internal resistance.

My fundamental principle for choosing a life of creativity is to do what comes naturally. I felt that if I was avoiding my own work then I must have strayed from that. But determining what's natural is not always easy. There is a line between letting things come as they will and laziness, and a line between working towards something and forcing it. Conscience is all we have to help us determine those lines, and this time I was lost.

At some point that month I received an e-mail from the Cartoon Art Museum about a

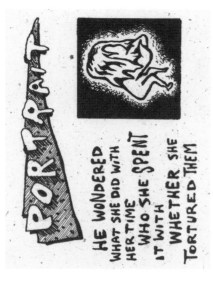

Portrait #4, 6.97

He wondered what she did with her time who she spent it with whether she tortured them

local news website, MisterSF.com, looking for cartoonists. Hank Donat, aka MisterSF, and also a columnist for San Francisco newspaper the *Independent*, wanted to host one artist a month to do a weekly cartoon on his site. I responded to the call for submissions and agreed to do four cartoons. I wanted to make something different from my weekly website postings, and the opportunity to create four stand-alone pieces excited me. It was a reminder that I had been productive with my weeklies, but had not been giving myself credit for them, only berating myself for the mess of the graphic novel.

I didn't know what I wanted to do for MisterSF so I stashed the project in the back of my head, wrote about it every few days, and waited for the seed to germinate. Joen returned from New York for a long weekend. I spent an afternoon at a lecture by Bob Mankoff, the cartoon editor at the *New Yorker*, and afterwards parked myself at a café. Over coffee I paged through my notebook and thought about the strip for MisterSF. It had been a month and I hadn't come up with anything solid yet. I was starting to worry that I had used up the enthusiasm of landing the gig, and would run out before actually creating something.

In my notebook I found conversations and scenes, most of which had nothing to do with my graphic novel. At a safe remove from my studio I saw how clearly I was betraying that story by constantly rewriting just to squeeze in all the vignettes. I knew better. I had put too much pressure on the story and was trying to fit all of my ideas into it. I needed to step back and create for the sake of creating.

The Mankoff lecture got me considering the simplest definition of irony: opposites. And I realized that opposites weren't just objects or ideas in relation to each other, but also the way they're approached. I decided to come at making comics differently, and strip down the form to its two fundamental elements: image and text. Rereading the vignettes in my notebook, I saw that instead of bending scenes to fit a character in the graphic novel, or bending a character to fit into them, one scene alone could be a strip. And rather than expand them, I could trim each one down. I held dozens of potential pieces in my hand at that moment, and countless others lay in notebooks back home.

Process was foremost in my mind. I wanted to get back to the how rather than the what, but the "what" was the product that people saw, a major issue not to be overlooked. I remembered a series of pieces I had done six or seven years earlier called "Portrait." Those pieces were similar to how I was thinking about these vignettes, but they weren't beautiful enough for me. And as I thought about it, I realized much of my recent work hadn't been beautiful enough for me. It was a hard pill to swallow, yet so obvious that I couldn't ignore it. If I was stripping down text and images as essential elements, what were their roles?

I had the idea of using these vignettes as stand-alone moments or short stories, but when considering what images I would make, I thought about how disappointing it is to see a favorite

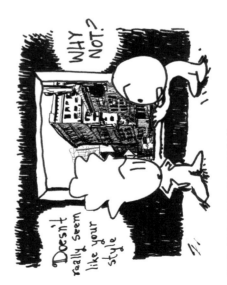

Doesn't really seem like your style

WHY NOT.

Website, Windows Series #2, excerpt, 5.1.02

landscape drawings. I remembered doing them, of course, but at the time had thought of them as sketches and exercise. They were stark renderings, primarily about light and shadow, done in pen and Sharpie. I wanted more richness for these new drawings so I mixed a dark and light solution of diluted india ink, gathered a couple brushes and one of each pad of paper on hand, then headed to a café in the Haight. It was a crisp and sunny day. I got a coffee, sat at an outdoor table and spread out my tools. I still used pen to lay down shapes, but applied shadow with brush and ink wash. I had worked with brush and ink when experimenting for the graphic novel, but I hadn't done drawings from life with these materials before. They were liberating, fast and full of life. The values (though rudimentary to my eye

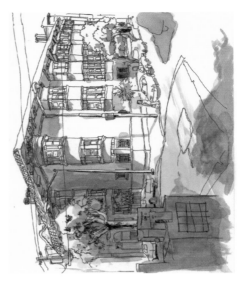

Cole Street, 9.03, first ALL OVER COFFEE *drawing*

life, and most importantly, make them the most beautiful drawings I could.

References began flashing before my eyes. I thought of the short stories of Chekhov, Kafka and Raymond Carver. Being in New York, I thought of Woody Allen's film *Manhattan*, an homage to the city's skyline, shot in black and white with moody and grainy light. I thought of Ben Katchor's drawings. His cityscapes in watercolor offered setting as a subject, which most cartoons only employed secondarily. I thought of Tony Millionaire, how a couple of his *Maakies* strips had only buildings. I thought about Gary Trudeau and his *Doonesbury* strips where dialogue floated above drawings of the capitol. And I thought of Edward Gorey's rich, theatrical scenes, a set that his characters walk onto. I now had a form of this new work in mind and began rewriting vignettes and sketching a layout. It would be a comic strip in the loosest of terms, its presentation would be such, but everything else would be opposite. Setting, not characters, would be my main visual subject, establishing tone while the text delivered character, story and idea. And there, sitting at a table drinking cappuccino outside a tiny coffee shop in the East Village, the idea for ALL OVER COFFEE was born.

THE FIRST THING I did on return to San Francisco was pack the graphic novel away to work on what would become ALL OVER COFFEE. I paged through the past year's sketchbooks and found city and

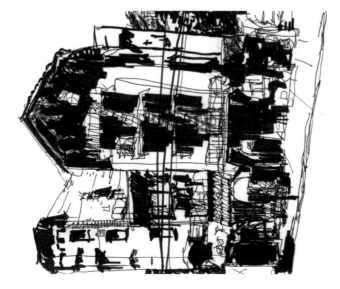

Sutter Street, 6.29.01

book turned into a movie, how the actors are never the characters I had imagined in my head. So I decided I wouldn't draw people for the strip. Instead, the characters' voices would float, leaving the reader something to dream on. Drawing was integral, of course, but the visual information couldn't steal from the reader's imagination. I had been drawing more from life under the guise of scouting for the graphic novel—it was what I was actually doing while telling myself that I was working on the story—so to accompany the vignettes, I would draw scenes and objects from

now) were invigorating, but halfway through the first drawing I got anxious, vacillating between gesture and getting mired in details. I needed to finish it. The owner of the café came out and looked over my shoulder—something I would soon have to grow used to—and praised the drawing. I was taken aback. I thought the drawing was good, but not great. It felt better to do it than it looked. I did three more drawings that day. The second sent shivers through me and amped me up. The third was a disaster, but I understood why. The fourth, too, was a mess.

Over the next few days I did more drawings and began to understand the new medium I had chosen. I established a wider range of inkwash values and acquired more brushes. I had quickly ruled out most type of papers and was working only on watercolor blocks. I experimented with texture until I found one that suited the drawings, then worked with strip composition and settled on a layout. By then I had narrowed names for the strip down to two: *Under a Wire Sky*, and ALL OVER COFFEE.

The strip needed a title that allowed for experimentation and ALL OVER COFFEE seemed to have endless possibility. Anything could happen over coffee. Cafés were the living rooms of a city, and for years I had left my books in cafes—that's how I met my wife! Then there was the subtle differentiation between the words "under" and "over." Something that happened under something else felt contained, whereas something that happens over something could drift on forever.

And then there was the obvious, that I had conceived this strip over coffee. The title settled itself.

With a dozen or so strips written, a pile of drawings, a format, and a title, I set out to make the four pieces for MisterSF. I knew how to approach this project: I would take all the writings and drawings I had been collecting and fit them together to see what I could make. The approach was to be backwards from however I previously thought about comics. This would be a strip with no characters, highly rendered drawings instead of loose, gestural lines, random pieces of text where the associations had to be deciphered, and no real punch line. I didn't worry about whether it was a comic strip. I thought of making ALL OVER COFFEE as I would a series of paintings or collages, and worked on all the pieces at once. I ended up

with six finished strips that I was happy with and showed them to Hank to pick four from. He took all six. The night before the strip launched on his site I panicked, hearing the title in the voice of a young hipster saying, "Dude, I am all *over* that." Everyone I told thought I was being funny.

The process of conceiving and creating the strip took about a month. The week after it launched I got the flu and was laid up for a week. At the end of the illness I spent a morning at the Kabuki, a bathhouse in Japantown, to help my recuperation. I was still in less than perfect health and thoughts of dwindling money were overwhelming. After the warmth and sauna of Kabuki I walked up Geary Street to Saint Mary's, also known fondly by locals as the "washing machine cathedral." The sky was grey and I sat on the steps looking toward the city watching the trees bending in the wind. The scene was beautifully composed and inspired me to draw. Along with my standard notebook, I had been carrying watercolor paper, pens, brushes and ink with me everywhere, so I began drawing the view. It filled me with energy and I believed everything might turn out alright after all. I decided that I would start doing ALL OVER COFFEE as the weekly strip on my website.

Panhandle, 9.03, second ALL OVER COFFEE *drawing*

THERE HADN'T BEEN much response from readers of MisterSF. A few e-mails, but for the most part I had no idea what people thought of the strip, or even if many people saw it. I thought of it

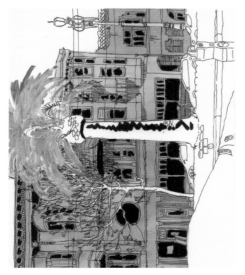

Castro, 9.03, third ALL OVER COFFEE *drawing*

as an art piece, not a viable series by any means, and I hadn't expected anyone to get it. Actually, I didn't even know what there was to get until the strips were all made, and that was part of what excited me about it. These pieces felt larger than something I could have planned. I didn't know what to do with the strip or how it would solve my money problems, but I was finally making work that excited me.

I was almost ten years out of college and had made some marks with my work, but all I could think about was that I had also been a bike messenger and a telemarketer, had worked in wood shops, an art gallery and museums, and I wanted to never have a job again. I knew how I wanted to spend my time, I just had to figure out how to pay the bills. It was important to get the work out of my studio and in front of people. I consid-

ered the strips as a book or in a show, but it was cartoonist Keith Knight who suggested I send it to the *San Francisco Chronicle*. I wasn't sure; ALL OVER COFFEE was one of the few things I felt was finished enough to put on an editor's desk, but it seemed too abstract for a mainstream series. The only way to know, though, was to send it out.

I sent the six finished strips along with a cover letter to about twenty newspapers. I couldn't abandon the graphic novel, though, so I unpacked and spread the albatross around my tiny studio. I worked on it all day, then grabbed a book and went to the local café. I was reading *Cat's Eye* by Margaret Atwood, and imagined scenes from her writing in ALL OVER COFFEE style. I returned home mid evening to a message on my cell phone, which I hadn't taken with me, from the *Chronicle*. They loved ALL OVER COFFEE.

I had read stories about authors getting their first book contract, stories about artists selling their first major work, and all had in common a sense of frozen time. When I listened to that message, I felt out of my body, as if I were looking down on myself at that moment. To this day, the only thing it compares to is when I met Joen. Every detail is etched in my memory. It's like time itself stopped and said, "Here, let me take a snapshot for you."

I didn't call the *Chronicle* back that evening— it was about 7 P.M. and in my mind they'd probably already left work for the day. I knew nothing about how newspapers worked. I just remember

being flabbergasted, thinking it couldn't be real. The next morning Joen and I talked about what it might mean and what questions I should ask. Breakfast is always a time of good conversation for us, and in the middle of our discussion the home phone rang. It was the *Chronicle*'s creative director, Nanette, calling again about ALL OVER COFFEE.

That call came in early November. I immediately—gladly—packed the graphic novel away again and for the next three months I waited impatiently for the strip to launch. I made only twelve new strips in that time, which seemed like a lot, considering that I had started out with only six. I'm not sure what I was thinking, really. The *Chronicle* didn't want to re-publish the first six strips, so after three months I only had the twelve new strips to launch with. Initially, the editors and I had planned the strip to run three days a week in the daily paper, but then at the last meeting before going to print I pitched a Sunday version, which the editors fell in love with. I was now on the line for twelve strips a month in a major newspaper. The editors gave me six months to see what I could do.

Shortly after that final meeting, the whirlwind picked up. I had twelve daily strips and two Sundays completed. I launched in the Sunday section of the paper and on SFGate.com, the *Chronicle*'s partnered website, which would also carry as well as archive the strip. On Monday the daily version of the strip launched, accompanied by an article about me and announcing this new

feature. Along with these debuts, I also drew the cover for the Sunday Datebook section (back cover image of this book). It was beginning to dawn on me how much work I would be responsible for. Somehow, three dailies had seemed manageable but now with the addition of a Sunday, I really needed to get to work. I had dozens of strips written and began drawing. Dozens quickly turned into a few. What I had thought was weeks of material turned out to be barely one, and I would have to do this every week.

THE DAY THE STRIP LAUNCHED, e-mails poured in. There was anger, confusion, and praise. One letter was from a man who'd read the paper on an airplane. He was moving back to Ireland after two years in San Francisco, retreating home to sort out his life. While the plane sat idle on the runway, stewardesses offered newspapers to the passengers, and opening to the cover of the Datebook section, the man saw the building he'd been renting an apartment in. "I knew then that leaving was the wrong choice," he wrote to me. A couple of days later, a friend of his came and purchased the original drawing for him. The drawing for the first Sunday strip sold that week as well. Then the owner of the building I had featured on the cover bought a print, since the original had already sold. Life felt rich with a serendipity I hoped would sustain itself, while knowing there was nothing I could do to steer it that way, other than to just keep doing what I was doing. My thought

was that San Francisco had endless beauty, so if I ran out of sites to draw and write for, it would be my own fault. How people responded would be up to them.

Over the next few months people began to recognize me while I was out drawing. I got everything from "Hey, you're that coffee guy!" to people knowing my name and other work I had done. The *Chronicle* continued to publish readers' responses where the letters of hate provoked letters of love, and a debate picked up with me on the sideline watching. I had never experienced anything like it with my work before. A high school English teacher began using the strip in his class and had students write to the paper. One of the letters read, "People don't want something that makes them think." Disheartening, but no surprise. A reader wrote and asked if I was "trying to make them feel stupid." I didn't know where to even begin with that.

I did my best to listen but not get derailed by people's opinions and suggestions—which came hourly—and just keep on track with what I thought worked. Confused e-mails continued to come, but so did new fans. "I was walking down the street," paraphrasing what more than one reader wrote, "and something about the light on the building made me think of your strip, and I finally got it." That reminded me of these moments I would have, usually while performing some mundane activity like washing the dishes or walking home form the grocery store, when I'd think of a movie I hadn't seen in years, remem-

ber a scene and a line, how a character moved, and a more nuanced understanding of what was happening would come to me. It was as if I had understood only its surface meaning when I first saw the movie, and then, years later, as if my brain had been working on the problem all this time, I understood a deeper level of subtext that I had initially missed. I called these moments time bombs, and thought about how art can act like a time-release capsule, slowly dissolving to release contents as needed. This reinforced my belief that the work held power that might not be clear to even me just now.

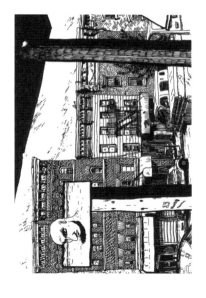

Brooklyn, 9.02

I wrote back to everyone who wrote to me, but had to let the angry e-mails go and just file those away in a folder. My only real response to those who didn't like the strip was a joke piece for April Fool's Day, 2004. It was created in one of

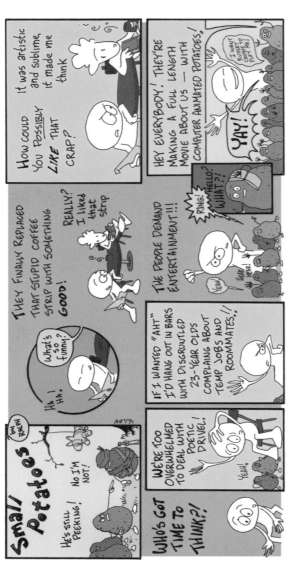

Small Potatoes, 4.1.04

my cartooning styles. "Small Potatoes" poked fun at those who didn't like ALL OVER COFFEE, but it was also meant to show that I could do other types of work, and that ALL OVER COFFEE was a choice in aesthetics, rather than a default. The *Chronicle* had a good sense of humor and was willing to go along with the gag. It was fun, albeit sarcastic, but in the end served only to divide more clearly the camps who liked and didn't like the strip. I did get some e-mails saying I should do Small Potatoes as a series.

As for actually explaining to readers what I was doing, I did little. I had my methodologies and concepts, but those didn't seem to matter. For those who didn't get the strip, they demanded to know what it meant. I understood that ALL OVER COFFEE wasn't like the comics anyone was used to in their daily paper. People wanted to walk away with a joke or gag, and my strip didn't have that. I couldn't make anyone change their expectation of the context, though. Only time could change that.

When I was uncertain about what I was doing with the strip myself, I struggled with where to look for perspective. No one was making work like this—at least, not with the same aims. I'd go to galleries or a museum. I read. Mostly, I found myself listening to Elvis Costello, Leonard Cohen, and Bob Dylan. The balance they achieve with words and music always helped me sort out a problem and progress with the work. It wasn't until I saw Raymond Pettibon's drawings that I found my first aesthetic measuring stick for ALL

OVER COFFEE. Our work was doing different things, but again, it was the balancing of text and image that I related to. Over time, his influence helped me clean some of the noise from ALL OVER COFFEE.

I WORKED on the strip seven days a week, my process in fast forward. Assembling the strips was the most fun; it was where the pieces came to life. I still worked in batches, making handfuls of drawings, having pages of possible stories, and composing strips from there. I generally turned in four strips, one week's worth, at a time. I was rarely ahead of schedule and often turned in a strip

hours before it was going to press, then began the process again. The *Chronicle* was patient with these last minute turn-ins, and I made sure never to miss a deadline. There was no time to reflect, but I had a sense that I couldn't know what I was doing until some time had passed anyway, so why bother. Just plow on for as long as possible.

The hardest part was that my scheduling was tied to the weather. I might have three strips to assemble and finish for the next day, but the weather would be unusually sunny and calm, so I would spend the day out scouting or drawing, then work all night to finish strips. I had to take advantage of what I couldn't control, and if

I spent a sunny day inside composing pieces, it could be raining the next day when I needed to go out to draw. The weather was a major stressor that I still wrestle with today.

By fall 2004, it felt like I had been doing the strip forever. With almost a hundred strips under my belt I was shocked to have made so many pieces. It had only been eight months. Since the Sundays and dailies were different formats, I thought of them as separate pieces and numbered them accordingly. The Sundays generally came with less effort and I usually made them after finishing a batch of dailies. All the strips were meant to be individual, self-contained pieces, but I had composed several of the dailies to work together as a series, the idea being that those strips could stand on their own but also be put together to form a larger piece. (I was already thinking about a collection.) The strip was enigmatic and held to such a loose formula to begin with, that it seemed to work, but the idea also cut close to the problem I had encountered with the graphic novel—was the strip maturing, or was I trying to use it to house all my creative desires?

Initially, I thought ALL OVER COFFEE couldn't be a serial strip, something you had to follow day by day to understand—it had been created under the concept of simplifying scenes, not expanding—but after several successful small three-to-five-strip series, I outlined and began a daily story planned to last a month. Though each strip would stand alone as a vignette, I stopped thinking about the strips as daily pieces and approached them as parts of a whole, and the results reflected that thinking. Many strips fell flat, functioning as passing tones, and because each strip wanted to also stand on its own, the overall narrative arc lacked shape. In attempting to create two experiences, both were compromised. And just like with the graphic novel, the scripting process got away from me. The intent was to make a 12-strip series, but the series ended up being 63 (strips 90–152), lasting 16 weeks. There were a few gems, but for the most part it was an exercise that I got entangled in, as well as costing me some readers. In the back of my mind I can see returning to the series some day and reworking all the elements as an illustrated novella.

As the four-month story line was concluding, Matt, the Chronicle's Art Director, asked me to come in for a meeting. Changes were being made to the back page of the daily Datebook section where my strip ran. The Chronicle had given me time and space to explore, but after wandering for the last four of the strip's eleven months, I figured a call to the office meant my run was over. Instead of cutting me, though, they offered the whole width of the page, making the strip a third larger. I was elated. It was a perfect transition. Reformatting was a way for me to rethink ALL OVER COFFEE and for readers to try it again. The strips that followed (153–200) are some of my favorites to date.

Now working in a larger format, I opted to cut one day a week, and the strip went to two dailies plus Sunday. I saw new potential for these pieces and started having fun again. I wasn't collaging anymore, but writing, then drawing with a connection in mind. I began to see the long story series not as an idea gone awry, but as an exercise where I learned intentionality. I had made it through the same quagmire I had abandoned with the graphic novel, and had come full circle to regain my trust in process. I felt as if I were

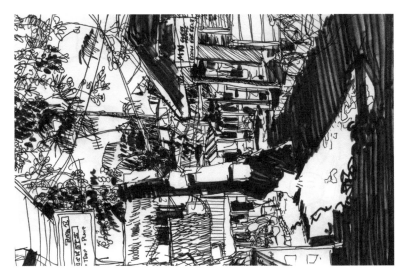

Koh Phi Phi, Thailand, 10.6.01

starting over and was relieved that the *Chronicle* had stuck with me along the way.

These new strips had more scripted interplay between text and image, requiring more time and scrutiny in writing, scouting, composing and editing. I couldn't know how much more these pieces required, though, and wouldn't admit that three strips a week of this caliber was too much work. To say that felt like failure. Pride was welling up in me. I had worked on my own for ten years before getting a chance to work professionally, to say now that the work was too much was to say I might as well go back to working in a woodshop. A fool's mistake, of course.

ALL OVER COFFEE had been running for a year and a half, and I was tired a lot, yet at the same time I had hit a new stride, conceiving and writing strips more quickly. I was aware that a new cycle had begun, like the first day I was at the café drawing or the day on Cathedral Hill. Slowly I began to accept that I needed more time with each piece. I met with my editors and we agreed that the strip should go to only Sundays. I was sad to let the dailies go, but the strip was born as a concept and process, so it was only natural that it wander to find its form. I had explored three different formats and found the one that fit best in the context I was creating for. Nanette, my editor, offered a suggestion: "Maybe it's backwards," she said, "maybe it's the other way around. You've been showing these rooftops and these details and writing the whole story. Show the whole scene and write the details." The advice

was magic and once more my thoughts returned to the strip's genesis: to come at the work backwards. Now, with only Sundays to do, I had time to work through ideas more and be selective, and ALL OVER COFFEE entered a new phase of endurance and maturity.

IN THE YEAR since going to only Sundays, creation and production time has been well balanced. Sunday strips generally came easier than the dailies all along, so now with only one strip to complete a week, pieces can sit on my table for weeks or months, if need be, before publication.

ALL OVER COFFEE has also been taken on a life beyond the paper and San Francisco. Pieces have been licensed for literary text books and other publications. Original drawings and prints are shown in galleries, cafes and restaurants several times a year, and I continue to sell work from my studio. Because the strip is archived on SFGate, I get e-mails from all over the world. Joen and I like to travel, and whenever possible we go someplace new and I draw while there. Most strips in this book feature sites in San Francisco, but several are of Paris, Amsterdam, and various regions of California.

The strip had many cycles where I felt I had started over, but the process and grace that has settled over the last year feels like the first complete cycle of cycles, so to put together a collection at this time feels appropriate. Though this is a book of individual pieces, I believe their col-

lection shows a journey from impulse to execution, from idea to form, and from will to creation, in both intention and creative discovery.

Collecting

I chose to do a book of selected strips after many conversations with Elaine, my editor at City Lights, and Alvaro, this book's designer. My initial intent was to do four small volumes: daily strips 1–89, the short story series, the wide dailies, and a collection of Sundays. Posterity was the idea. Also, formatting a book of three different formats of strips seemed awkward. ALL OVER COFFEE had never been presented in book form before, though, so I let go of the strip as an entity and came at the collection as a project all it's own. I was making a book, not just a pile of all the strips with a cover. Looking at the strips from this per-

Haight Street, 2.6.04

spective, I saw that many had similar elements that diminished the power of others. Some were passing tones. Some just didn't work. Cutting strips then became easy. Decisions were made on merits of individual pieces as well as their contribution to the book as a whole. At the time of embarking on this collection, 320 strips existed. I cut the reviewing off at strip 309 because it felt like the end of a series, and a comment on the reviewing process (though it wasn't written with that in mind). The strips after 309 seemed to possess an awareness of scrutinizing the work that came before.

Deciding to do a selected book of all formats compromised two aspects of the work. Both are small compromises, though, and only worth noting for the sake of noting. A few Sunday strips were done in a tall vertical format, which could not be accommodated. And several series of strips were done as horizontal panoramas, where, if laid side by side, two strips would form one image. Only one of those series is in this book, Sunday strips 5 and 6 (pages 28–29).

For the most part, strips are presented in order of publication date. A few are out of order for the sake of composition or to keep a series of strips intact. Edits have been made to some pieces. In the case of the short story series, only a few of those strips are presented here, chosen as individual pieces, and edited with focus on the vignette rather than the narrative. Other than that, I did my best not to attack strips with today's eye, but to tighten what I know my original intentions to have been. Primarily, edits were to the text, punctuation and tense corrections, and some redesigning to reveal more of the image. A few pieces here have different images than what they were originally published with. In reviewing the work for this collection, I was struck by what I believe would have been obvious next choices had I left myself more time before going to print. With these, each replaced image is from the batch of strips the original piece was created with. Those pieces I've made such seemingly dramatic edits to now feel finished.

It doesn't seem necessary to note each altered piece; however, two stand as exceptions. Daily strip 120 (page 81) was made in Paris with diary-like text on the original drawing. When published in the Chronicle, that text was replaced with a vignette from the short story series. The original text is presented here. The second exception is daily strip 171 (page 110). Initially published as two strips, like daily strips 162 and 163 (page 101), the image was cut in half horizontally so that when one strip was placed on top of the other, the complete image was formed. I liked the composition of both pieces individually, but felt the power of light was lost by having cut that image in half, and since strips 162 and 163 demonstrate the novelty of the stacked panorama, I chose to present 171 and 172 here as one strip in the Sunday format.

Every piece in this book was published in the *San Francisco Chronicle* and on SFGate.com, except for Sunday strip 14 (page 53), which was the only piece I turned in that didn't get published. It was early on, and taught me that I needed to pay attention to holidays. The strip muses on falling, jumping, or pushing someone off a cliff, and if it hadn't been pulled, that piece would have run on Mother's Day. It was an honest mistake. I love you Mom.

—Paul Madonna, Fall 2006

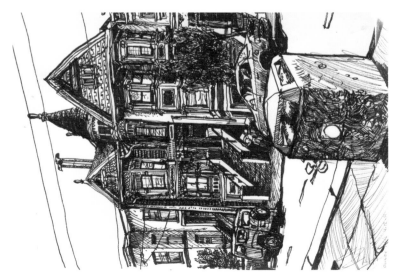

Hayes at Central 4.12.01

ACKNOWLEDGMENTS

To the people who have helped me with ALL OVER COFFEE.

Thank you, Scott Borchardt, Hank Donat, John Hessen, Elaine Katzenberger, Suzanne Kleid, Keith Knight, Stacey Lewis, Louis Menand, Dave Misconish, Jim Neczypor, Chris and Denise Parsons, Danielle Svetcov, Rebecca Throne, Alvaro Villanueva, Faith Wheeler, the Cartoon Art Museum, and Digital Pond.

Extra thanks to Nanette Bisher, Matt Petty, David Wiegand, Joe Brown, the *San Francisco Chronicle*, and SFGate.com.

Thanks to Mom and Dad, because you're Mom and Dad and I don't need a reason to thank you, other than the thirty-four years of ongoing support that got me here.

And I give the honor of the last word, with love and gratitude, to the person I simply can not do without. Joen.

All Over Coffee

Paul Madonna

ABOUT THE AUTHOR

Paul Madonna moved to San Francisco and began to self-publish comics after graduating from Carnegie Mellon University's fine arts program and spending a winter as the first art intern at *Mad* magazine. In 2002 he launched his popular website www.paulmadonna.com, posting a new cartoon each week. In 2004 the *San Francisco Chronicle* and SFGate.com picked up ALL OVER COFFEE, which continues to appear weekly. Original drawings from the strip are shown throughout the year and prints are available at www.allovercoffee.com. Paul lives in San Francisco with his wife, Joen.